HAUNTED
PUBS, INNS & HOTELS OF
DERBYSHIRE

HAUNTED
PUBS, INNS & HOTELS OF
DERBYSHIRE

JILL ARMITAGE

AMBERLEY

First published 2011

Amberley Publishing
The Hill, Stroud
Gloucestershire, GL5 4EP

www.amberleybooks.com

Copyright © Jill Armitage 2011

The right of Jill Armitage to be identified as the Author
of this work has been asserted in accordance with the
Copyrights, Designs and Patents Act 1988.

All rights reserved. No part of this book may be reprinted
or reproduced or utilised in any form or by any electronic,
mechanical or other means, now known or hereafter invented,
including photocopying and recording, or in any information
storage or retrieval system, without the permission in writing
from the Publishers.

British Library Cataloguing in Publication Data.
A catalogue record for this book is available from the British Library.

ISBN 978 1 4456 0464 0

Typesetting and Origination by Amberley Publishing.
Printed in Great Britain.

CONTENTS

Introduction	7
Ashbourne	9
Ashover	12
Bakewell	15
Baslow	17
Birchover	18
Bolsover	19
Bonsall	20
Brassington	21
Brough	23
Calver	24
Castleton	25
Chesterfield	27
Clay Cross	38
Cromford	39
Darley Abbey	41
Darley Bridge	43
Derby	44
Dronfield	56
Earl Sterndale	60
Edale	61
Eyam	62
Froggat Edge	65
Great Hucklow	69
Hardwick	70
Hartington	72
Hassop	76
Hathersage	78
Lea	81
Longshaw Estate	82
Makeney	84
Matlock Bath	86
Middleton by Wirksworth	88
Miller's Dale	89
Mosborough	91
North Wingfield	96
Oakerthorpe	98
Old Whittington	100
Owler Bar	102
Pomeroy	103
Rowsley	105
Shardlow	106
South Wingfield	109
Stoney Middleton	111
Swarkstone Bridge	113
Taddington	114
Tansley	116
Ticknall	117
Tideswell	118
Tupton	119
Wardlow Mires	120
Winster	122
Wirksworth	126

INTRODUCTION

We all enjoy a spot of recreation, especially if it culminates in a drink or meal at the local pub, a smart town-centre bar, a scenic village inn or a historic country hotel. But if you fancy somewhere different, why not come with us and discover some of Derbyshire's haunted pubs, inns and hotels? We delve into their history and piece together folk memory, evidence and anecdote to uncover a wealth of evocative tales and some fantastically spooky stories. Augmenting these with the claims of psychics and paranormal investigators, we will encounter the hauntings that have baffled such investigators, and terrified landlords, cleaners and customers for generations.

We find these hauntings in the old alehouses – often farmhouses that sold their own home brew to weary travellers along the packhorse routes. Many still exist and Derbyshire is rich in these ancient establishments. With the advent of the coaching era came the coaching inns situated at major road intersections. They offered food, drink and accommodation for travellers and stabling for their horses. Modern-day visitors frequently report hearing the sounds of those long-gone days. There are claims that phantom coaches and horses still hurtle past, and that coachmen haunt many of these old buildings. The coaching era also saw the advent of the highwayman, and now, rather belatedly, many old inns claim to have had the custom of some of our most notorious highwaymen, whose ghosts are said to haunt their premises.

Merchants would meet at inns to undertake business. Inns also provided rooms for the local circuit judges to hold courts, for council meetings, and for the buying and selling of animals. In times of national crisis they acted as recruiting offices. Doctors, dentists and vets held surgeries there. They also served as post offices and the old lead miners were paid there, subsequently passing a large percentage of their earnings back over the bar. They were an ideal place to use counterfeit money and sell corpses for medical purposes. It's these kinds of activities that have given pubs their 'haunted' reputations.

There are famous spirits – such as Florence Nightingale, Little John and Charles Cotton – plus a wealth of anonymous Roman soldiers, monks and Cavaliers who still linger. There are serving wenches and former landladies, playful spirits and heartbroken maids, victims of crime, animals, former residents and patrons.

Inns acted as temporary morgues for locals whose tiny cottages allowed no space for a deceased family member to be laid out. In times of accidents and disasters, corpses would be taken to the nearest pub to await identification and burial. Airmen who crashed over Edale, navvies killed while digging a mile-long railway tunnel under Clay Cross, and the forty-five men and boys killed in the Parkhouse Mine disaster were all taken to the 'local'. It's generally believed that quite a few of these disaster victims decided to stay.

Staff and customers often work on nothing more tangible than their senses to account for a lot of the strange phenomena that happen in many haunted buildings. Often they

report what can only be described as a peculiar atmosphere or the feeling of being watched. On a slightly less sinister note, everyday items go missing, glasses shatter and chairs are known to move on their own. Beer taps and lights mysteriously turn on or off, doors jam or swing open for no obvious reason. Staff and customers often report strong smells of tobacco smoke, more evident now since the smoking ban came into force in 2007. There are the sounds of ghostly footsteps, voices, rattling glasses, pots and pans. People have reported being pushed, nudged and pinched. There's the rather unnerving experience of feeling a hand on the shoulder, yet turning round and no one being there. It's not unusual to experience cold spots, and mysterious sightings have been caught on CCTV.

Haunted Pubs, Inns & Hotels of Derbyshire takes you deep into the places where people have seen ghosts, heard them and – most frightening of all – felt them. These places with their hidden secrets are closer than you might think, so if you encounter any form of apparition, whether it's an anonymous white lady who drifts across your hotel bedroom or old Fred come back to see his mates at the pub, do let us know.

Jill Armitage

ASHBOURNE

The Playful Ghost at the Green Man and Black's Head Royal Hotel

Ashbourne, or Esseburne as it was named in the 1086 *Domesday Book*, is believed to mean 'brook by the ash tree', which is still quite a good description for this attractive medieval town that nestles neatly on both sides of the Henmore brook. Ashbourne developed as a thriving market town, owing much to its position as a meeting place of six main coaching roads served by a variety of coaching inns. One which has retained this old-world atmosphere is the Green Man and Black's Head Royal Hotel, a mid-eighteenth-century inn with an unusual and rare gallows sign which spans St John Street. Look at the Black's Head. On one side he's smiling; on the other he's sad. The coach entrance to what were once the stables behind is now a covered courtyard, but guests still report hearing the indisputable sound of a coach and horses negotiating its passage through the yard, a throwback to the days when this was a busy coaching inn.

It's a town centre pub with character and, according to the cleaner Doreen (name changed on request), a playful ghostly character too. She was cleaning one of the public bars when she saw a pair of salt and pepper pots glide across a table by the window and stop just short of falling off the table top. She automatically reached over to put them back in the centre of the table and they immediately glided back again. She ran.

Doreen also told me about the scene when a guest staying in Bedroom Two had an unexpected service call. The lady, who was in bed at the time, heard a knock on the door and a maid entered. The guest watched in stunned silence as the maid walked across the room and disappeared through the wardrobe door. Could this be the ghostly figure that people in the street have seen looking out of one of the bedroom windows?

The Base Coiner of Ashbourne Searches for His Gold

There are many historic buildings still to see in Ashbourne and some have interesting stories to tell, but none more so than the Royal Oak, just off Market Place at the junction of Buxton Road and King Street.

In the early eighteenth century, the landlady of the Royal Oak Inn fell for the charms of a man named George Ashmore, and while they cohabitated above ground he spent most of his time in a workshop hewn out of the rocks on which the Royal Oak Inn stood. The problem was that George may have been gainfully employed, but his employment was illegal: he was turning out fake guineas and crown pieces. A busy coaching inn like the Royal Oak would have had no problem passing these off as the real thing among the constantly changing coach parties passing through Ashbourne.

Ashbourne's pub with the longest name has a playful ghost.

The Royal Oak was the centre of operations for the base coiner of Ashbourne.

However, his activities couldn't go unnoticed indefinitely and, as the romance cooled, the dissatisfied landlady read a notice offering a handsome reward for information leading to the detention of the 'base coiner of Ashbourne'. She realised that her subterranean lover was worth a substantial amount and the temptation was just too great. She was no doubt also keen to save her own neck, so she informed the authorities of George Ashmore's whereabouts. He was arrested and carted off to Derby gaol. Understandably, no one wanted to be duped with counterfeit money and all the bad publicity meant that trade at the Royal Oak trickled away to almost nothing. The landlady no longer enjoyed the sizeable income she had previously and must have regretted her hasty decision.

Counterfeiting carried the death sentence. After George's execution, relatives came forward to claim his body and carried it away to the churchyard at Sutton on the Hill. His remains were interred on 29 August 1740, but several days later it was noticed that the newly occupied grave had been disturbed. As feared, on closer examination George's corpse had disappeared. All that remained was the empty coffin.

When it became known that George had been a victim of body snatchers (see the Froggat Edge story), rumours were rife that the discontented lover had traded his dead body to the resurrection men to make a bit more money.

Poor George! It's not surprising that his ghost is said to haunt the site of the old Royal Oak. Whether he's seeking revenge or buried gold – the genuine article – is uncertain, but there's no wonder that George Ashmore, the base coiner of Ashbourne, can't rest in peace.

Catherine Mumford

Catherine Mumford was born in a cottage in Sturston Road, Ashbourne, on 17 January 1829, but she is better known by her married name of Catherine Booth, 'Mother of the Salvation Army'. She would have been a familiar figure around the local hostelries, as she regularly preached about the demon drink and tried to promote total abstinence. To include her in this book might seem rather strange, but it is said that if you go to the recreation ground, where you will find her statue, on the stroke of midnight she will wink at you – especially when you've had a few drinks.

The statue of Catherine Booth in Ashbourne's recreation ground is said to wink on the stroke of midnight – especially if you've had a few drinks.

ASHOVER

Ashover is an old-world parish situated in the beautiful Amber Valley. It was mentioned in the 1086 *Domesday Book* as 'Essovre', meaning 'beyond the ash trees', although the village was probably in existence when the first ever taxation survey of England was made by King Arthur in 893. The centre of Ashover, with its fourteenth-century church, has been designated a Conservation Area, thus ensuring that this delightful village retains its character. In 2005, it won Calor Village of the Year. A century ago, there were twenty or more shops, making the village almost self-sufficient. Now there are just three, including a well-stocked post office. There are also three very popular pubs and two of them are haunted.

Seventeen Spirits Frequent The Crispin

Next to the church is the fifteenth-century Crispin Inn. It could have been named in recognition of the Battle of Agincourt, fought on St Crispin's Day on 25 October 1415, or it could have been named after Saint Crispin, the patron saint of cobblers, saddlers and harness makers – these trades were at one time the main occupation of many of the village men.

A few centuries ago, The Crispin was also a cobbler's shop. Early records show that it was the residence of the Wall family, shoemakers and publicans. It is one particular Job Wall who is immortalised on the large wall plaque outside the inn that states that in 1646, during the Civil War, he refused admittance to the King's men, as they had drunk too much already. They ignored him, threw him out, and posted a guard on the door while they drank the alehouse dry.

On 26 October 1995, The Crispin featured in the *Derbyshire Times*: 'Ghoulish goings on at a North Derbyshire pub are really putting customers in the Hallowe'en spirit.' The article went on to list no less than seventeen ghosts including monks, cavaliers, itinerants, animals, former landlords and children.

Nine years later, in July 2004, The Crispin was taken over by new owners who almost immediately set about much-needed architectural surgery. Retaining the pub's authentic ambience, they not only achieved a transformation that is sympathetic to the building, but they also disturbed the ghosts.

Workmen were traumatised by numerous unnerving experiences and admitted that they regularly felt something or someone behind them giving them a push. Upon the completion of the work, customers began reporting feeling strange sensations, particularly drops in temperature or cold draughts often referred to as psychic breezes. While dining at The Crispin, I have experienced this – although no one else at the table did.

Above left: The Crispin is said to be haunted by seventeen spirits.

Above right: The Cavaliers at The Crispin drank the house dry, so it's not surprising to find some have stayed in spirit.

Customers regularly report being touched. My own experience is of a rubbing sensation on the back of my legs. As I looked down I expected to find a cat or dog hovering under or round my chair, yet there was nothing to be seen. On one occasion, the background music suddenly blurted out at full volume. No one had been near the music centre, yet the knob had been turned to maximum.

I took a photograph of the empty dining room and discovered that I'd captured a large spherical disc of light on the back wall. My first thought was that it was flare from the wall lights, so I took another picture from exactly the same place a few seconds later and the orb was not repeated. Orbs are believed to be the first manifestation of a ghost, picked up by increasingly sensitive technology.

Andrew, a previous licensee living on the premises, had two young children and while working in the kitchen felt a child throw its arms round his legs. As he hadn't heard either of his children enter the kitchen, the childish embrace was quite unexpected, but seconds later as he looked down he was amazed to find that he was quite alone.

On another occasion, a wall clock in the hall stopped working. Thinking it might have got moved or knocked slightly, Andy tried nudging it gently back in line. It started to tick, but after a few minutes stopped again. He tried again and it went for a few minutes then stopped. Later he tried again, but without success. Next day he tried yet again and got the same results; so, telling the clock that it was only fit for firewood, he left it. Next morning, when he went downstairs, he passed the clock and not only was it going, but it was at exactly the correct time. Andy was initially rather surprised but

reasoned that it was obviously his wife Michelle who had managed to get it to go and set it to the correct time. When he saw her, he commented on this.

'I never touched it,' she exclaimed in surprise. 'I thought you must have managed to get it to go.'

There was no one else in the building who could have sorted out the clock, so the situation remains a mystery, particularly the fact that the clock has continued to work and is still at the correct time. So was it a fluke or one of those seventeen spirits that frequent The Crispin?

Phantom Cavaliers and Cows at the Black Swan

Just down the road from the Crispin is the Black Swan. TV viewers might recognise this 300-year-old pub which was featured in the Derbyshire-based ITV series *Peak Practice*, a medical drama that ran from 1993 to 2002. It's thanks to the many locations used in filming *Peak Practice* that Derbyshire and its stunning scenery was brought to the attention of millions, and local residents remember the chaos and confusion caused when the cameras rolled in Ashover.

The black swan is a very atypical bird and interesting symbol. It became a popular inn sign in the eighteenth century, and the way that landlords showed their disapproval when the Gin Act of 1736 was imposed. This act meant much higher taxes, and in protest many licensees draped their inn signs with black velvet or added 'black' to the inn name, thus making the Swan into the Black Swan.

This popular village pub also appears to have residual energy left over from the Civil War, which is understandable when considering its location. Down the road is the Crispin Inn where Royalist troops turned out the landlord and drank the house dry, and the ruins of Eastwood Old Hall – which was destroyed by Cromwell's army – is only a short distance away. This area was certainly very active during the Civil War (1642–51) and there are reports that a Cavalier haunts the upper rooms of the Black Swan. But he is not alone.

Two previous licensees and family members have experienced various forms of paranormal activity. A few years ago, Simon Oxspring, the landlord, saw the ghostly figure of a woman walk along an upper corridor and simply melt into the end wall. The figure was so clear that he couldn't ignore the incident. He subsequently discovered that a door had previously been located in the wall which divided the domestic quarters from the stables where black horses and the horse-drawn funeral hearse had been housed.

Incorporated on the eastern side is a two-storey building that used to be thatched. This was a butcher's shop in the days when butchers had their own adjoining slaughterhouses and they butchered animals on the spot. People have reported hearing the mooing of cows around here, even though there's no sign of any in the immediate vicinity – so could this plaintive sound date from the slaughterhouse period?

BAKEWELL

The Rutland's Ghosts Defy the Smoking Ban

Bakewell is often referred to as the 'Gateway to the Peak District'. It is the largest and most important town within the boundaries of the Peak District National Park and attracts thousands of visitors, drawn by its scenic beauty, its array of interesting shops and the opportunity to sample a genuine Bakewell pudding.

To discover the origin of this popular delicacy, we need to go to the Rutland Arms Hotel, the impressive Georgian hotel in Rutland Square where, according to the legend, Mrs Greaves the proprietor entrusted the making of a dessert to her kitchen maid. The maid was confused and got the mixture wrong, but guests at the hotel were delighted when they sampled the new dessert which is now known worldwide. We can't guarantee that you will smell anything quite as delicious as this happy accident, but many hotel guests regularly report the smell of tobacco smoke, which is now even more obvious after the smoking ban. But does the ghost of Mrs Greaves haunt the Rutland Arms Hotel?

Strange Happenings at the Smithy Inn

The Smithy Inn, as its name would imply, had been the old whitesmith's forge on the side of the market. Although it has now been converted into shops and offices, during the 1980s it was a fourteen-bedroom hotel. For security reasons all rooms were automatically kept locked and, when they were occupied, each guest took possession of their own key. That's the way it works in all hotels, yet there was one room at the Smithy Inn that had all the signs of being occupied without any evidence of a guest – at least not a physical one. The bed never looked rumpled, but in the bathroom the towels, normally neatly folded, were often found damp and crumpled on the floor. There was never any evidence that the shower or the washbasin had been used – not even an odd water droplet – yet there were often signs of condensation on the windows.

Another room in the old part of the Smithy Inn always seemed to have a distinctive smell. It wasn't unpleasant or particularly strong but it was persistent and could not be accounted for. One lady who stayed in that room woke in the night to see a young woman feverishly searching through a set of drawers which in the cold light of day had no physical existence.

Above left: Bakewell.

Above right: Does the ghost of Mrs Greaves haunt the Rutland Hotel?

Harriet Haunts The Peacock

A barman at The Peacock went down into the cellar and, when he tried to return, found the door had mysteriously jammed. He banged and shouted, but despite there being many people in the public bar no one could hear him. He tried to use his mobile phone but couldn't get a signal. Eventually he managed to climb up the barrel chute. As he walked in through the door, people looked at him in surprise and asked where he'd been. When he told his story, they went to check the cellar door and found it opened easily and there was no means of locking or blocking the door. At other times, staff have found the beer taps turned on or off in the cellar, lights go on and off for no reason, and three men standing at the bar saw a ghostly figure in the doorway. She has been identified as a former landlord's daughter named Harriet.

The old stables adjoining The Peacock have now been converted into holiday lets. Last summer, one group of guests staying there explained to staff that they hadn't locked the rooms because they had left the maid in there. The staff looked puzzled. There was definitely no maid that fitted the description of a lady wearing a long dark dress with a full white apron over it.

BASLOW

Baslow is one of the most picturesque of Derbyshire villages, sitting on the edge of Chatsworth Park. It has a number of first-class hotels and restaurants, and of these the most haunted appears to be the Wheatsheaf Hotel. This is a much-altered former coaching inn on a major turnpike road.

The coaching trade had became highly efficient by the 1820s and coaching inns played an important role. It was usually the individual innkeepers who bought or hired stagecoaches from the manufacturers and organised the whole system networking the country. It was a multifarious business. These coaching inns were very busy places providing stagecoach passengers with food and drink and overnight accommodation. They also catered for wealthier passengers with private carriages and for horseback travellers. Some inns were post houses, where the mail was collected and deposited for the local area.

To maintain high average speeds of 8 to 10 miles per hour for stagecoaches, 10 to 12 miles per hour for mail coaches, it was necessary to change the teams of horses every 8 to 12 miles, depending upon the difficulty of the route, and the horses needed rest, food and water before they could be put to work again. For every team of four horses required to pull a coach, a spare horse was necessary in case one needed to be replaced through illness or accident, and this meant that the larger coaching inns had stabling for numerous horses, providing work for ostlers (stable hands), grooms and farriers (blacksmiths that shoe horses).

It would appear that it is a former ostler at the Wheatsheaf who now haunts the place. They say that he walks across the bridge that used to link the former courtyard stables to the main buildings of the hotel – except that the bridge that he uses disappeared many years ago. Apparently he has been seen more than once passing through the outside wall and moving across a bedroom, but who he is and why his spirit has lingered is unknown.

The Wheatsheaf is on the eastern edge of the village of Baslow and would have been the last stop before the coaches made their lonely progress along the bleak East Moor. It would be another 7 miles before coaches reached the environs of Chesterfield, and the route even today passes only remote farmhouses and a few clusters of cottages. Coaches travelling across this lost landscape would have provided plenty of opportunities for that predatory beast, the highwayman, to strike.

BIRCHOVER

Dramatic Disclosures at the Druid Inn

Birchover is rich with evidence of primitive man's presence in the form of stone circles, megaliths and the impressive Rowter Rocks – reputedly an ancient Druid stronghold. Rowter Rocks command the most amazing views and it's not difficult to see why an ancient site like this has long been regarded as a place of power where unusual forces can manifest.

At the base of the rocks is the eighteenth-century Druid Inn, although this could have been constructed on the site of an even earlier building. As more and more legends became woven around Rowter Rocks, early landlords at the Druid Inn sold tickets and acted as guides; their conducted tours continued well into the twentieth century.

I was interested to find whether any of the wealth of evocative tales associated with Rowter Rocks had carried to the Druid Inn, but no one seemed able to confirm this. What I did find, however, is that there's a kindly old lady with a warm, caring smile who is alleged to sit in the corner of one of the downstairs rooms.

After partaking of the hospitality of the Druid Inn I questioned the waiter, but my enquiries seemed to be going nowhere when a magazine that had been on a unit in the corner of the room suddenly fell on the floor. There was no draught and no one near it, so it was strange that just one of the many books and magazines there should have fallen. As the waiter picked it up, I recognised the magazine as one that I occasionally write for. I laughed as I pointed this out; but as I took it from the waiter, it fell open at one of my articles. I stared in disbelief. This was more than a coincidence. What are the odds against that kind of thing happening? I strongly believe that the little old lady was aware of my presence and decided to show me.

The Druid Inn, haunt of a friendly old lady who made her presence known.

BOLSOVER

Ace of Clubs Ghost Captured on CCTV

Bolsover is perhaps best known for its magnificent fairytale castle perched on the limestone ridge above the valley of the River Rother and the M1 motorway. But a few years ago this was an industrial and colliery district of considerable importance. Since the closure of the mines in the 1980s, there are few traces of mining in the area, but we discovered a former miners' welfare club at Bolsover that has been converted into the Ace of Clubs public house – and it's haunted.

One evening as Julie Birch, the manager, was locking up, she caught a movement on the CCTV screen which set her heart racing.

'I didn't know what it was, but it seemed to be running across the back room from the kitchen,' Julie told the *Derbyshire Times* reporter. 'I was so scared I got out as soon as I could.'

When Julie told her friends, no one believed her until they saw the footage, which shows an orb-like orange ball speeding across the building.

'There have also been times when something has just flown off the side or fallen off the wall randomly,' said Julie. 'If this is some elusive visitor it would appear that he has a penchant for real ale, as I've also snapped a spooky figure lurking behind the taps. It's possible to make out a face hovering behind the bar, but it's all rather a mystery.'

Does a miner haunt this former miners' welfare club?

BONSALL

Barley Mow UFO Sightings

The sleepy village of Bonsall is the last place you'd expect to find paranormal activity, yet Bonsall sprang to prominence in the millennium when a national newspaper proclaimed it the UFO capital of Britain.

Apparently over a hundred unidentified sightings by what were considered sober and reliable sources have been recorded in the skies above Bonsall and Slaley in the past thirty years, but when local residents Sharon and Hayden Rowlands shot a 6½-minute video which allegedly showed a UFO, this gave visual credibility to the stories.

The Rowlands were at home one night watching television when Sharon spotted a bright light in the sky and rushed outside with her camcorder to record the event. The press got hold of the story and it even reached Los Angeles; Fox is reported to have acquired exclusive rights to the film. No documentary has appeared as yet, but UFO enthusiasts from all over the world have visited the village of Bonsall, and the landlord of the Barley Mow conducts UFO walks for interested parties.

The Barley Mow, where you can join a UFO walk.

BRASSINGTON

Paranormal Investigators at Ye Olde Gate Inn

Brassington is now made up of largely seventeenth- and eighteenth-century houses, yet its history dates back to the Romans and a road called The Street that once ran through the village. This road has remained in continual use since Roman times, and in 1738 this stretch was turnpiked to ensure its improvement. The term 'turnpike' comes from the early practice of stabbing a pike in the road to stop access until a fee had been paid. As this old inn was built in 1616 and stood on this stretch of turnpike road, it's likely that Ye Olde Gate Inn took its name from the gate across the road – an improvement on the pike. Apparently there was a small window specially constructed in the side of the pub, where passing coachmen would be served a drink.

This quiet seventeenth-century pub was altered in 1874, so it's not surprising to find that it's a traditional pub with a range, scrubbed wooden tables along each side, a stone-flagged floor, low ceilings and exposed beams. The pub exudes atmosphere, nowhere more so than in the downstairs dining room with its wall-to-wall oak panels and open fireplace. The building has witnessed centuries of activity. During the Civil War it was used as a temporary hospital after a nearby skirmish, and a number of customers have reported mysterious sightings and odd feelings.

The landlord, Paul Burlinson, will tell you about the experiences of two lads who not so long ago took their drinks into the old dining room. Suddenly they rushed out, ashen-faced, saying they had seen a mysterious old woman in a turn-of-the-century dress, sitting by the fireside. They were so scared, they left the pub immediately and didn't even finish their drinks – and it was only their first round!

In 1998, a group of paranormal investigators spent a night in the pub and noted the heavy atmosphere, rushes of cold air and the way their candles flickered oddly. One individual complained of splintering headaches, another felt he was being hit on the head with a heavy weapon, while another was convinced she was hearing the sound of nearby stabled horses. It is possible that they were all in tune with the inn's history, so beware – this quiet village pub has a strong paranormal past.

Above: Creepers have totally covered the swinging sign at Ye Old Gate Inn.

Left: But the one over the door is still clearly visible.

BROUGH

Is the Travellers Rest the Home of a Lost Legionnaire?

The Romans reached lowland Derbyshire in the first century AD and built a fort at Brough-on-Noe. They called it Navio, which means 'place by the river', as it's here where the River Noe is absorbed by the River Derwent. The chief purpose of the fort was to police and supervise the adjacent lead mining areas, acting as a mining depot and transit centre at the intersection of a number of Roman roads.

The Roman occupation of the Peak District has left us with a number of cases of paranormal activity, so when I learnt that the Travellers Rest at Brough – located just outside the walls of the Roman military station of Navio – was haunted, I imagined finding tales of Roman legionnaires and gladiators. Sadly this is not so. There appear to be no Roman legionnaires, but the Travellers Rest does have several spectres, including a ghostly occupant dressed in black who carries a bunch of keys. She was seen several times by a former landlady, Mrs Dora Happs.

There is also the story of a young farm girl who visited the Travellers Rest one Christmas Eve. She no doubt wanted to enjoy the season's festivities, but she was pestered by a drunken farm labourer who wouldn't take no for an answer. In order to get out of his way, she ran blindly out of the room and fell headlong down a spiral staircase to her death. Her spirit is said to return every Christmas Eve to haunt the place where she met her untimely death.

The 1974 Christmas issue of Sheffield's *Star* carried a photograph showing the then landlord, Con Sullivan, purportedly keeping watch with a flickering candle among the beer barrels in the cellar. Whether the distressed spirit appeared is not reported, but Mr Sullivan admitted to having felt a presence in the inn. On one occasion, he felt someone touch him on the shoulder but, turning round, he found the room was empty and the door was closed. Mr Sullivan is not the only one. Customers have also reported feeling an unseen presence so if it's not the ghostly lady dressed in black or the farm girl who met with an untimely death, perhaps it could be a Roman legionnaire after all.

CALVER

Practical-Joking Landlord at the Derwent Water Arms

Calver lies on the west bank of the River Derwent, which gave its name to this unusual inn overlooking the village cricket green. It has long been reputed to be haunted by a former landlord who was in the habit of playing practical jokes. One evening he lay on the parlour table and got his wife to cover him with a sheet. She was then instructed to go into the bar and tell his customers he had died suddenly.

Naturally the customers expressed their condolences and the wife invited them into the parlour to pay their respects to the 'corpse'. They gathered round the table in a sympathetic silence then suddenly the 'deceased' sat up and terrified his audience.

However, the following day the landlord was driving to Bakewell in his horse-drawn trap when the horse suddenly shied. The man was thrown and broke his neck, so that evening he actually lay on the same table, but this time he was a genuine corpse.

Various landlords have since reported hearing unexplained footsteps and being aware of an inexplicable presence. Regular visitors would not stay in one of the bedrooms and, deciding to investigate, the landlady and her niece slept in there one night. They occupied the double bed while a maid had a single bed in the corner. At midnight, the door opened and a menacing presence entered the room. It stopped to view the occupants, walked round the bed, paused again, then left the room. Could it be the ghost of that landlord playing another of his practical jokes?

The Derwent Water Arms, haunt of a previous landlord.

CASTLETON

Ghostly Characters at Castleton

Castleton gets its name from the Norman castle that dominates the village or 'ton', which has become one of the Peak District's premier tourist destinations. Castleton also has its fair share of ghosts. I spoke to a council workman who swore he had seen a Cavalier riding down the main street early one morning; a chamber maid who couldn't close certain wardrobe doors until the ghost allowed her to; and English Heritage staff who man the castle, which is definitely haunted.

But of all the pubs and hotels in Castleton, the Castle Hotel must rate as the most haunted since it boasts of having at least four resident ghosts. If you fancy an overnight ghost-hunting vigil, book into the hotel; the ghostly guests will do their utmost to entertain you. Renovation work carried out in 1996 provoked an increase in sightings and supernatural activities, so you might encounter the jilted bride who walks along the corridor to the raftered dining room where her wedding breakfast was set many years ago, ready for the feasting that would follow her wedding at the local church.

The unfortunate lady in her wedding apparel had been forsaken at the altar, so her guests never attended the cancelled reception. She apparently died of an inconsolable grief but appears back at the Castle Hotel, where a maid who saw her white-gowned figure in wreath and veil ran screaming downstairs to tell her story. The bride was again seen by another witness, who observed that she was wading knee-deep in the floorboards.

Another former landlord, who took over the tenancy in 1962, saw the misty figure of a woman proceeding along an upstairs corridor, as though wading deep in the floorboards. To say he couldn't believe his eyes is rather an understatement, but when he later studied the plans of the hotel's alterations he found that the floor of that corridor had been raised during construction work. The altered height meant that the spectre was in fact walking on the original floor level.

There's a nurse, a girl who was murdered in 1603, and a legless soldier (I'm not sure whether he's without limbs or drunk) who haunt the cellar. There's a small elderly grey lady, believed to be a former housekeeper called Agnes, who also drifts through the passages, but she doesn't appear to have any connection with the chambermaid who haunts room four on the first floor. In May 1999, a séance was held in the room and the medium made contact with the spirit, who said her name was Rose. As well as performing her normal duties as a chambermaid, she also tended the hotel's flower gardens and sold flowers to the guests, but why she should remain, and the significance of room four, are still a mystery.

One evening a male guest, Councillor T. J. J. Weaving, saw a small, grey-haired lady in a grey dress standing on the other side of the glass-panelled door of the main

Above left: The beer gardens of the Castle Hotel offer the view of the castle on the hillside.

Above right: The ghost of a bride haunts the Castle Hotel.

bar. He stepped smartly forward to pull open the door for her but, as he did so, she disappeared.

A former landlord and his wife, Mr and Mrs Phil Williams, who took over the licence in 1960, were busy tidying up late one Hallowe'en night when Mrs Williams remarked that someone had just walked past the frosted glass window of the taproom. Her husband assured her that it was not possible as all the doors were locked; but just to pacify his wife, he went into the taproom to check. Much to his surprise, standing with his back to the fire-surround was a man in his mid-fifties wearing a pinstriped suit. His hair was turning grey and he stood with his hands clasped behind his back; but when Mr Williams spoke to him, he simply disappeared. Phil Williams returned to his wife, ashen-faced and with his heart beating like a drum.

But the man in the pinstriped suit isn't just confined to the taproom. Apparently another landlady, while ascending the stairs, met a man; in order to allow him to pass, she stood aside, at which point he simply vanished. She also averred that the man was wearing a blue pinstriped suit. A bit of investigation has uncovered a possible explanation and a name for this phantom. He is believed to be a local man named Mr Cooper, who lived on nearby Castle Street in the early 1900s. He was a local lead miner, but every Sunday he would get spruced up in his good suit and go for a drink at the Castle Hotel. The story goes that he died one Sunday while downing his pint in the taproom and has been returning regularly since to finish it off. And yes, his good suit was pinstriped.

CHESTERFIELD

Chesterfield is Derbyshire's second largest borough. Its history can be traced back to the Romans and no doubt it became a trading centre for the adjacent mining areas which even before then were producing lead and iron. Chesterfield possesses one of the architectural curiosities of the age: the crooked spire of the church of Our Lady and All Saints. The town has excellent shops, a theatre and numerous pubs, so we sought out the haunted ones.

Spectres at the Sun Inn

The Sun Inn has been described as Chesterfield's most haunted pub. Cold spots and a peculiar atmosphere are evident in many parts; objects have moved, doors have opened and closed of their own account and the ghost of a woman has been seen on many occasions. A family group saw her glide through the lounge, while others have seen her on the stairs. One family member woke to find her standing at the bottom of her bed and on another occasion felt the bedclothes being pulled off.

A previous landlord was woken by sounds of strange music and, thinking the jukebox had been left on, he hurried downstairs and immediately noticed that the unearthly sound was coming from the cellar, not the lounge. The cellar door, which he knew he had locked before going to bed, was open. It is not known whether he went down the cellar to investigate, for unearthly happenings seemed to manifest themselves in the cellar of the Sun Inn and the family's German Shepherd dog would not even go near the cellar door.

A report in *The Star*, the Sheffield evening newspaper, reported that around midnight one night in November 1957, the landlord, Mr Vincent Holmes, heard a terrific crash and found empty bottles were strewn around the cellar floor. Restacking them, he tried to convince himself that the crates had fallen over, but he knew this was highly unlikely.

On 16 October 1980, the *Derbyshire Times* ran a story on the hauntings of the Sun Inn, aided by the licensees at the time, Stuart and Susan Hibbert. In 1986 the then landlord, Mr Les Rowlands, recalled how the beer pumps had mysteriously stopped working and, hurrying down to the cellar, he found the valve handles turned off.

And things are still happening. On the morning of my visit in May 2005, the licensee, Craig Sleigh, had been down in the barrel room when he heard footsteps behind him. Thinking it was his wife Ann, he began talking to her then froze as he realised he was alone; he shot upstairs and downed a stiff drink. This was only an hour before my visit and regulars who had witnessed this were still in the bar to confirm the story told to me by Ann Sleigh. She said that sounds are heard in the cellar as if a man has been

The seventeenth-century building of the Sun Inn is on the left, with the market hall in the background, as seen in a somewhat blurry image taken in the early twentieth century.

The Sun Inn of the later twentieth century inherited its predecessor's ghosts.

locked down there, and customers' dogs (not permitted now after the considerable and attractive open-plan revamp) refuse to go anywhere near the cellar door. I was also told of a Victorian girl, aged around ten, who appears to be grounded not in the cellar but upstairs. She has befriended the Sleighs' eleven-year-old daughter and the family call her a tease because she regularly moves things.

So why does this inn have so much paranormal activity? Some of it can be traced back to the time when the Sun Inn was a busy coaching inn. The basement and cellars are part of that original seventeenth-century inn, and there are in fact two capped wells in the cellar, fed by an underground spring. The story that might account for the activity in the cellar is about a coachman who had brought in a coachload of hungry passengers. Tired and hungry, he stabled his horses and left his coach before going into the inn, but some time that evening he was murdered, probably for any money and valuables that were in his safe-keeping. His body was thrown down the well, 80 feet below the cellar level, and no one missed him until the next morning, when the passengers were ready to depart. No wonder the poor unfortunate coach driver is trying to alert people to his plight!

Phantoms at the Golden Fleece

The Golden Fleece occupies a 75-yard-long strip between Chesterfield's High Street and Knifesmithgate. This town-centre pub is haunted by Cheeky Charlie, a mischievous rather than ancient or mysterious spirit. He is thought to be Charles White, once an alderman of Chesterfield and landlord in the nineteenth century of one of the four pubs that once occupied the site between Knifesmithgate and High Street, now taken up by the Golden Fleece.

Helen Cooke, wife of landlord Glyn, will not remain alone in the upstairs rooms, and the couple's dog howls and whines if anyone tries to force him upstairs. A previous landlord called in a medium, who told him there were definitely ghosts there, but they were friendly enough. However, Charlie can create havoc when he is in the mood. He seems to be free to roam and spends a good deal of time in the bar and cellars. Staff have gone into the cellar to connect new CO_2 cylinders, only to find the empty one reconnected a few minutes later. Gas and beer taps are turned on and off, bottles and cleaning equipment are moved, and in one incident a member of the bar staff watched in amazement as a glass flew through the air behind the bar, hitting the kitchen door, only to be found standing unbroken on the floor.

The Pushy Ghost at the Loft Bar

The Courtyard used to be an old schoolhouse; later it was converted into shops and more recently a lounge bar called the Loft Bar, run by Phillip Richardson Wood.

One day, while concentrating on a pile of paperwork, Philip was given a violent push that sent him sprawling over his desk. He whirled round to confront his attacker, but found that he was quite alone. Until then he might have blamed the wind for

The Loft Bar, where Phillip Richardson Wood was pushed.

the strange noises that often sounded remarkably like footsteps walking across the floor, or the peculiarities of an old building that made the cellar door bang closed. But what caused the strange movement of furniture, the tinkling of glasses, and the feeling of being poked? These are just some of the strange happenings that people have encountered in this building. The Courtyard is a very apt name for this watering hole since it has a charming courtyard hidden away behind the building. It's a really pleasant town-centre oasis, but it's also haunted and it could be because it was once part of the graveyard of Elder Yard Chapel. It still possesses a few gravestones dating from the end of the nineteenth century to prove it.

The Watchful Spirits at The Rutland

The Rutland stands on Stephenson's Place next to the Crooked Spire. It's made up of at least two distinctly different buildings, and at one time the red-brick building overlooking the churchyard was the verger's house. During renovation work, workmen repeatedly found their tools went missing – only to reappear in a totally different place. Apparently a medium called in for a drink and sensed the presence of two friendly spirits: a man in the former verger's house and a woman that wanders round the place.

People who have seen the male ghost describe him as wearing a dark cloak. They also sense there is a religious connection – perhaps the spectre was a previous verger. 'We

The Rutland has changed but the spirits have remained.

call him Fred,' said Jane Randall, the current tenant. 'He seems harmless and amicable enough, so we just share the place.'

Jane often feels a presence watching her as she cleans, and sometimes the feeling is so strong that she turns to check who is actually behind her – only to find that she is alone. Glasses have been seen to move along a shelf then drop to the floor without breaking. In the cellar the gas switches off, and the water supply to the ice-maker is regularly switched off. It is thought this could be the work of Hannah Owen, who in 1875 worked at what was then called the Rutland Hotel. But why should a former barmaid still haunt her previous place of employment? It can be traced to a Victorian tragedy that happened there on 19 July 1875, when Hannah hanged herself from the rafters.

Now, over 130 years later, many people believe that Hannah's troubled spirit has never left the Rutland Arms. The white figure of a young woman glides down the stairs and across the bar to leave at the far end. One man who saw her said she was so clear that for a moment he mistook her for his daughter.

Squabbling Spirits at the Gardeners Arms

This town-centre pub was originally called The Grape but became the Gardeners Arms in 1870. There's a long-standing belief that an outgoing manager will see the figure of

an old man sitting in a certain chair in the bar, but most have experienced the pub's regular spirits way before then. Loud noises like squabbling are often heard coming from upstairs. Often the sounds are so loud they can be heard above the normal chatter in the bar. Footsteps are also heard, closed windows are found open, and taps are turned on.

The cleaner, Janet, was vacuuming the carpet in the bar and had gone as far as the flex would allow. She switched off the machine and walked to the plug, but suddenly the machine started up again. As she turned instinctively, she saw a shadow of a figure dart behind the bar and disappear. It was so fleeting she couldn't be sure whether it was male or female, but the only place it could have gone was down the cellar, which is very spiritually active. Various members of staff have experienced something down there, but Jamie categorically saw a man so clearly he thought he was a customer. He was just about to inform him that the cellar was out of bounds to customers when the man promptly vanished.

Replaying Murder at the Royal Oak

The Royal Oak stands on the corner of Iron Gate in the very centre of the Shambles. According to a plaque outside, it was built in the twelfth century, is the oldest inn in Chesterfield, and one of the oldest in England. That is not strictly accurate. It may be one of the oldest buildings, but it was originally a small dwelling house and did not become licensed as an inn until 1772, when it was extended into two adjacent buildings to provide stabling and a brewhouse. A further extension of the property took place in the mid-nineteenth century, when two butcher's shops were purchased by George & William Batteson, maltsters, who then owned the property. It is from this time that our story originates.

The buildings along either side of this narrow collection of streets were dwelling houses, abattoirs and butcher's shops. John Platts was one of the butchers who had a shop in the Shambles, and George Collis, who worked as a servant to the Barnes family at Ashgate House, had invested heavily in this joint business venture with Platts. However, the arrangement wasn't working, and on the chill winter evening of Sunday 7 December 1845, 26-year-old George Collis met John Platts in the Old Angel Inn near the Market Place and informed him that he intended to withdraw his money and move to a new life in Manchester.

This obviously provoked an argument, and later witnesses were to report seeing two men pushing a third, who seemed heavily drunk and unsteady on his feet. This caused no undue alarm in a rough area renowned for its drunkenness and prostitution. The men went into John Platts' shop, next door to the Royal Oak, and locked the door after them.

People reported hearing blows, moaning, and the sound of something heavy being dragged along the floor. Those who banged on the door asking what was wrong were told by Platts that he had drunk too much and was sick but would soon be better. A light burnt in the shop way past midnight but cloths covered the windows, making it impossible to see inside. On Monday the shop stayed closed all day, but that evening

The Royal Oak, Chesterfield.

three men were seen carrying what looked like a sheep pack out of the Shambles. They crossed Low Pavement and into Bunting's Yard, now Falcon Yard.

When Collis's absence was noted, suspicion fell on John Platts; but as no body was found, people believed that Collis must have gone to Manchester as he had planned. Then, on 28 August 1846, men emptying the cesspit in Falcon Yard discovered Collis's decomposed body. Platts was brought to trial at Derby Crown Court in March 1847 charged with wilful murder. He was hanged on 1 April 1847.

When the butchers moved from the Shambles into the newly constructed market hall over a hundred years ago, the Shambles changed dramatically and the Royal Oak was extended into the two neighbouring butcher's shops. One of these was the infamous butcher's shop that had been rented by John Platts. After that, even people who have never heard about the events on that dreadful Sunday night started feeling a strange, uncomfortable atmosphere. A psychic saw the faint figure of a man wearing a black hat and coat, while managers and staff frequently have the feeling they are being stared at. There is one particular corner where people don't like to sit. There is no doorway to cause a draft, yet it has a coldness that can't be accounted for – an occurrence so common in haunted properties that it is usually referred to as a psychic breeze.

Clubbing with the Spirits

Holywell Cross Methodist Chapel – later the YMCA hall, and more recently Livingstone's nightclub – has had a few transformations but retains its ghosts. Even from those early days as a chapel, there are tales of intense temperature fluctuations and noises that couldn't be accounted for. Members of the congregation saw doors open and close with no explanation as to how or why. Shadowy figures were seen and people felt they were not alone.

During the chapel's time as a YMCA hall, four young men who had decided to form a rock group were practising there. After they had finished, three stayed behind to pack up the equipment. Suddenly they all experienced a drop in temperature, then one of the boys seemed to fall into a trance-like state. Much to the surprise and horror of his colleagues he began commenting on a church sermon as if he was actually in that other time during which the building was a chapel. As the temperature returned to normal, he seemed to come round and could not remember anything about what had happened.

More recently, staff have reported hearing footsteps following them down corridors. One evening after everyone had left and all the doors were locked, one member of staff went down into the kitchen, where she encountered a man wearing a hat and an old mackintosh. Thinking he was an intruder, she went and raised the alarm, but no one was found and all the doors were still locked. Apparently this figure has been seen so regularly it has been given the name Mickey.

Elsewhere, while revellers enjoy themselves upstairs, in the basement of the Montmartre nightclub the taps turn on and off, figures are seen in mirrors, and bottles and crates are moved by unseen hands. It has been suggested that these events are caused by the spirits of those disturbed when the building, once a warehouse, was created by digging up part of the ancient churchyard of St Mary's.

The Somerset House Spirit that Flew Away

Somerset House is situated at Calow, a residential parish on the eastern outskirts of Chesterfield and the site of the Chesterfield Royal Hospital. It's still semi-rural and Somerset House, now a pub, was formerly the house of a gentleman farmer who, like many others, participated in the rural pursuits of shooting and fishing.

However, one day in 1934, a day's shooting was to end in tragedy when the ten-year-old son of the farm labourer who lived in the adjoining cottage picked up a gun to play with. He imitated the adults he had observed, aimed the gun at his seven-year-old sister, and fired. His game had gone horribly wrong. The gun was loaded and the little girl died. She is buried in St Peter's churchyard, Calow.

Shortly afterwards, the building became a pub, and subsequent landlords, customers and staff have experienced strange phenomena. On numerous occasions, customers have seen the apparition of a young girl – and the description always tallies with that of the victim. One man was so sure it was a flesh-and-blood child that at first he thought it was his own daughter until he realised she was safely at home, tucked up in bed.

Somerset House tenants firmly believe that this tragic little spectre is to blame for the strange occurrences that frequently happen. Items at the back of a shelf have fallen off without disturbing items in front of them. Doors will suddenly and unaccountably refuse to open. Lights will refuse to switch on or off. On one occasion an electrician

Somerset House, scene of a fatal tragedy.

was called. He could find no reason for the problem, then suddenly the lights just began working normally again.

Staff hear their names being called by a mystery voice. In 1988 Carol, the barmaid, woke to find scratches on her arms. Claims that she could have scratched herself in her sleep were discounted because her nails were bitten short. Bill Davis, the landlord, then pulled up his shirt to show similar scratches on his back. They too had appeared overnight and, because of the angle, could not have been self-inflicted.

In 1990, Bill and his wife Shirley had a visit from their son Peter and his five-year-old son, who live in London. The little boy got up in the night to go to the bathroom and saw the girl. He had been unafraid, but later asked who the girl was and why she had 'flown away'.

Newbold Pubs with Spirit Strife

Newbold is a residential parish on the western outskirts of Chesterfield, and can lay claim to two haunted pubs: the Devonshire Arms on Occupation Road, and the Nag's Head on Newbold Road.

According to Alf Matthews, landlord of the Devonshire Arms, nobody is allowed in the cellar without his knowledge, but he had gone down there on several occasions and found five beer barrels, weighing 7 cwt each, had been moved around. His dog, a cross between an Alsatian and a Doberman, refuses to go down there, so Alf decided to take action. He called in the Chesterfield-based Paranormal Research Bureau.

Taking up the challenge to investigate, the group had an interesting time. They heard noises in the dead of night as though someone were knocking the barrels. One member felt she was being suffocated, a record flew out of the jukebox just missing two of the team, and the recording equipment refused to function.

The Nag's Head on Newbold Road can trace most of its paranormal activity to its site because at the rear is the tiny Eyre Chapel, built as a chapel of ease for the Roman Catholic Eyre family in the thirteenth century. Since its attendees were frequently persecuted for their faith, over the years this little chapel has been systematically ransacked and looted, decimated and destroyed. Graves have been trampled, tombstones removed to use in local buildings, and part of the graveyard is now the car park of the Nag's Head.

In recent years, the chapel has been restored but the whole area is known to be very spiritually active. Landlords of the Nag's Head, their families and customers have regularly reported hearing phantom footsteps both in and outside the building. What makes these so disturbing is that they are described as being quick and heavy. There are also echoing sounds like chanting, which is often accompanied by strange lights. When going to investigate, people have seen the indistinct shape of a hooded figure lurking around the ancient chapel.

A local landlady told this story to Mr L. Atkins, a devout churchman of New Whittington, but sadly I wasn't told the name of the pub or the landlady concerned, only that it occurred in this area. Apparently the landlady frequently saw a hand reflected in a mirror as though it were beckoning to claim her attention; but when she

turned round, there was never a visible hand to match the reflection. This happened so regularly and so unnerved her that she approached the brewery to ask for the mirror's removal. Permission was granted, and when the mirror was released a recess was found in the wall. In the recess was a box containing a large sum of money and a will dictating the terms of its disposal. Investigations revealed that the three beneficiaries of the will were still alive and able to enjoy their inheritance. The mirror was replaced and the hand never appeared again.

The Armchair Ghost at Ringwood Hall

Ringwood Hall was originally Brimington Hall, a Georgian, Grade II-listed manor house built early in the nineteenth century for the Markham family, Chesterfield industrialists and benefactors. Now it's a very smart hotel and leisure complex, but the Markham family seems to have left its mark in more ways than one. Staff have seen vaporous figures walking along the corridors, and a few years ago a security guard spotted a ghostly figure sitting in an armchair in the hall. The manager was a disbeliever until he witnessed a ghostly glow around a portrait of the late Vanessa Markham, so it's highly likely there are a few spirits around that are not of the liquid variety.

Ringwood Hall.

CLAY CROSS

The Morgue at the George & Dragon

At the top of Clay Lane is an eighteenth-century coaching inn, the George & Dragon. Old buildings automatically come with a history – the George & Dragon is no exception. It was probably a farm that was converted to an alehouse around 1755 and did a roaring trade a century later when hundreds of navvies flooded into the area to build a tunnel for a new railway line between Leeds and Derby.

As the navvies dug through the wet shale, they unearthed extensive deposits of coal and iron ore, and it was these pockets of mineral wealth that inspired George Stephenson to form a company to market them. Thus the Clay Cross Company was formed and Clay Cross was changed from a rural to an industrial centre.

When the Clay Cross Tunnel was completed in August 1839, it had a length of 1 mile 24 yards (1.6 km). However, accidents had been frequent, and it is thought that eleven men were killed during construction. The bodies of these men were brought to the George & Dragon, which acted as a temporary morgue, and it's believed that these men still haunt the place. The present landlord is rather vague about it, but the George and Dragon has definitely got an atmosphere.

The George & Dragon was used as a morgue for the men killed while digging the Clay Cross tunnel.

CROMFORD

The Boat Inn is Awash with Spirits

Before 1770, Cromford was little more than a cluster of cottages around the fifteenth-century packhorse bridge with its wayside chapel; but things were about to change with the arrival of Richard Arkwright, who had a bright idea for the mass production of yarn and cloth. He needed a reliable and controllable source of water, which he found at Cromford. So, having chosen his location, in 1771 Richard Arkwright set about building the first successful water-powered cotton mill, which was to start the transformation of textile manufacturing from a cottage industry to a factory-based one. The mill complex is now a World Heritage Site.

The village of Cromford was built to house the mill workers and it provided shops, a school and a number of pubs. Although some parts are believed to be older, the Boat Inn was built around 1772 as a flour merchant business, but by the early 1830s it was being used as a brewhouse known as the New Inn. The first known landlord, Anthony Boden, not only brewed and sold ale, but he was also a butcher and used the premises to sell his meat and slaughter his animals. According to auction details in September 1865, it was described as having a brewhouse and slaughterhouse, and in that same year it was owned by William Allen, a boatman on the Cromford Canal who changed the pub's name to The Boat. It still retains the name and it also happens to be one of the most haunted buildings in Cromford.

The Boat is not unaccustomed to change, but when Bill Gates, a previous landlord, changed the beer cellar into another bar/function room, he got more than he bargained for. The builders knocked away an old fireplace containing bread ovens, and behind this found a room that stretched under the road to Scarthin. The room was empty, but that night, Bill was woken by noises coming from the cellar area.

Glasses were being smashed and a sound like the crash of a pile of beer trays had to be investigated; but as Bill crept downstairs expecting to see total destruction, he found nothing.

Bill was totally bewildered and pondered on how these noises could have been made when the room did not even contain a bar. This noisy destruction continued for a week, then stopped.

That's when the footsteps began.

These footsteps – walking along the first floor – still continue today, according to the present landlord, but the scariest thing happened to Bill Gates' thirteen-year-old son.

Bill went out, leaving his son alone in the pub; but to make sure the boy was safe, Bill locked all the outside doors. It wasn't long before the boy heard footsteps and he ran to hide in one of the downstairs rooms where he could lock the door securely from the inside. (This is the room where the pool table now stands.) The footsteps approached

the door and he waited and watched in horror as the doorknob began to turn. When Bill returned, he found his son in a state of sheer terror.

Voices, materialisation and mischievous spirits are all active at the Boat Inn. There is also a sad story attached. Alice, a young girl, was apparently kicked to death by horses in what was once the stable of the inn. It is believed that she is now grounded there. She is said to be responsible for taps being turned on. She calls the names of people working in the bar, particularly that of the last person there at night. Alex, who is one of the staff, has actually seen her. One day Alex was fooling about and locked his colleague Ken in the cellar. As he pocketed the key, Alex turned to see a little girl, about six years old, standing a short distance away. She was wearing a white dress with a broad sash and was scowling at him. She obviously didn't like Ken being locked in the cellar.

Numerous soldiers have been seen in uniforms ranging in period from the eighteenth to the twentieth century.

The Royal Ancient Order of Buffalos had their meetings in the basement bar of the Boat Inn. After he left, Bill Gates kept in touch with the Reverend Louds, who has now died, but who told him about the following episode. A meeting of the Royal Ancient Order of Buffalos was in progress when suddenly, without any warning, a lady in grey materialised, walked straight through the assembled group, and disappeared in the far wall.

The Boat Inn must be the most spiritually active building in Cromford.

DARLEY ABBEY

Monastic Spirits at the Abbey Inn

Darley Abbey is a substantial suburb just off the A6, north of Derby. A few years ago it was separate village, but the history of Darley Abbey and the name date back to 1140, when this was the site of an Augustinian abbey founded by Robert Ferrers, 2nd Earl of Derby. It was the largest, richest and most important monastic establishment in Derbyshire. The abbot was granted many privileges in Duffield Forest and Chase, and the monks operated the original Derby school. Like other monastic establishments, it was surrendered as part of the Dissolution of Monasteries in 1538; Henry VIII ordered its termination and ultimate destruction. Its demolition was so thorough that the precise location of the abbey's extensive buildings has long been forgotten, although several houses were built using the stone and timber, and have the foundations of the abbey beneath the earth in their gardens.

The only surviving part of the actual abbey is the building on Darley Street thought to have been used as the abbey guesthouse for travellers and pilgrims – rather like a modern-day hotel. In 1980, this building was sensitively restored and converted into the Abbey Inn, and during renovation twelfth-century pottery and a few skeletons were unearthed, so it's not surprising to find that it has its share of monastic spirits.

Residents and visitors regularly report seeing monks and hearing distant music. Numerous people have stated that they have heard monks chanting. There are also reports of a strange person dressed in dark clothing walking a dog near the Abbey Inn, but the most reported sightings are of two monks and a white lady.

But not all hauntings are outside the Abbey Inn. Staff have reported a strange atmosphere inside, particularly round the fireplace area. Customers have also felt themselves being pushed by invisible hands. Men have felt or sensed someone or something in the gents' toilets and surrounding area.

Although nothing has been seen, the landlord, staff and guests have all felt scared when at the back of the pub, as if they are not alone.

The Abbey Inn.

DARLEY BRIDGE

Mischievous Spectre at the Square and Compass

Rather confusingly, Darley Bridge has no connection with Darley Abbey. Darley Bridge is in the delightful Darley Dale that links Rowsley and Matlock. And, as its name implies, this is the bridge that crosses the River Derwent, a popular venue for fly-fishing. The Square and Compass sits almost on Darley Bridge and has a mischievous spirit that opens and closes doors.

A mischievous spirit opens and closes doors at the Square and Compass.

DERBY

The county town of Derby only received city status in July 1977 in formal recognition of its standing as a major industrial and commercial centre. This meant that unlike many medieval cities, there is no great, impressive cathedral, and the parish church of All Saints became Derby Cathedral. Derby's growth embraced many of the villages which once stood on its fringe and today the changes to the city centre make it a delightful shopping centre with theatres and some great pubs, many of which are haunted.

George Haunts the Seven Stars

The Seven Stars, just past the junction of St Helens Street with the A6 (Duffield Road), was built in 1680 on the site of St Helen's Augustinian monastery. Originally it was called The Plough – the astrological sign, not the farming implement. Although its name has changed, the inn sign has not and still shows the seven stars in the shape of a plough. It has always been known as a haunted pub with footsteps and figures being seen in the bedrooms and attics, and in recent times electric lights and beer taps going off and on inexplicably. The present tenants have given the ghost the name George. Could the hauntings have anything to do with the ancient well discovered in the early 1960s which can be seen through a glass panel in the floor of the bar today?

The Friars at the Friary Hotel

The name Friar Gate refers to the ancient religious foundation, the Black Friars, who built a friary near the site of the present Friary Hotel. After the Dissolution of the Monasteries, the friary became a private house and passed through several hands before it was demolished. The present building dates from around 1730 and was built with stone from the original building. When workmen were digging out the foundations and cellars, they are said to have disturbed human remains, but rather than remove these, a decision was made to leave them there. Could this be the reason for later happenings?

One evening the undermanager of the Friary Hotel was drinking with customers at the bar when he saw a headless figure dressed in a black robe disappear through the panelling of the room. Several minutes later, he felt himself being pushed roughly against the bar. A former waiter claimed he once met a black-robed friar in one of the basement corridors before the apparition vanished through a wall.

While the property was still a private house, Henry Mosley, a Victorian printer from the Wardwick, owned the building, until in 1857 he shot himself. More recently, guests have reported seeing a man in Victorian dress walking round the hotel and through the

The Friary.

bedroom walls. Some describe him as wearing a top hat; others say he holds his top hat in one hand and taps the ground with a stick held in the other. He has such a dejected appearance that his sadness seems to permeate the area around him and is known to affect any person who sees him.

The Condemned Man at The Greyhound

This old pub dates back to 1734 and is in the heart of 'the Derby mile pub crawl' along Friar Gate, although some of these pubs have been lost over the years. The Greyhound might have been one of them. It was forced to close four years ago because of the recession, but it reopened and at the time of writing still retains its original name. Staff and customers have observed the ghost of a lady wandering around the building on numerous occasions, so two students decided to do an all-night vigil. There was no one else present, yet they heard footsteps, scratching, and knocking sounds within the building. One of the students took a photograph and the picture revealed a misty substance in which appeared to be seated a lady with a pleasing countenance and old-style dress.

But the lady doesn't appear to be alone, and The Greyhound's close proximity to the local gaol could account for others. The Friar Gate Gaol was built in 1756 on the site of 50–51 Friar Gate. The Greyhound is No. 76.

Those prisoners who had committed a capital offence would be sentenced to be hanged on the gallows situated at the highest point of the town. This was guaranteed

to provide an ideal vantage point for the masses to enjoy the spectacle, because all executions in this country were public until 1868. On the day of execution, something of a holiday atmosphere would prevail as sightseers would flood into Derby from all parts of the county. The condemned would leave the gaol and climb onboard a wagon which would be driven along the street lined by jeering spectators. The wagon would make slow progress and, as it approached a pub, those inside would rush out to view the condemned, who would be bought a complimentary drink. Having consumed this, the procession would continue. Once the last pub before reaching the gallows was passed, there was no more drink and the condemned was 'on the wagon'. That's where the phrase originates.

It is believed that it was one of these condemned men, brought here to The Greyhound for his last drink, who still haunts the building.

Spirits at Seymour's Wine Bar

On Cheapside, tucked away beside St Werburgh's churchyard, is Seymour's Wine Bar, and the two locations appear to share a ghost or two.

People have seen strange orbs of light that have been captured on camera in St Werburgh's churchyard, which is said to be haunted by a number of spirits. A former worker at Seymour's on several occasions reported seeing the ghostly figure of a man walk through the wall into the building.

Seymour's most encountered ghost is a Victorian lady dressed in grey who seems to prefer the upper floors of the building. Her watchful presence was often felt in the area known as the Bake House. Staff have felt themselves being touched by unseen hands, but at no time have they ever felt threatened or in any danger or harm. Usually her appearances are foreshadowed by the smell of lavender. It's reportedly so strong that it stings the nostrils. Staff claim that she wanders round the place, moving glasses and bar tools, often hiding them in unusual places. Cutlery on pre-set tables was found to have been moved around and placed in a different order, and some things go missing and don't turn up for days or weeks – and when they do they are often in totally inappropriate places.

Dead Bodies and Dodgy Deals at Ye Olde Dolphin Inn

Ye Olde Dolphin Inn is one of Derby's oldest pubs, dating back to 1520, although parts were rebuilt in the eighteenth century. Understandably for a building of this age, it has acquired numerous ghosts, including a young girl and a lady in blue who walks through the old lath and plaster walls. The latter has been seen by many customers in the pub and in the upstairs tea rooms but her identity is unknown. It's doubtful whether she is the poltergeist that turns off the taps of the beer kegs in the cellar, but someone does. Ghostly voices are often heard on the intercom that links the bar with the cellar. Staff regularly refuse to go down there, certainly not alone, but that's not surprising when you consider the cellar's other uses.

When the eighteenth-century rebuild took place, one section which is now incorporated into Ye Olde Dolphin Inn was the home of a Derby physician. In those days it was essential for physicians to expand their knowledge, and to do this they needed cadavers or fresh corpses on which to practise anatomical research and dissection.

From the time of Henry VIII, the only human bodies available for medical examination were those of executed criminals; but even though the death penalty was applicable for a large number of crimes, in the late eighteenth century only about 200 people were hanged in the whole of England and Wales.

After a hanging, the body, if not claimed by relatives, would be sent to the local physician, often to be dissected before a room full of eager medical students. There are tales that some poor souls were not dead when they arrived on the surgeon's table, and woke on the dissecting slab, in which case they were dumped in a corner where they were watched to see if they would live or die.

Medical knowledge was advancing but not fast enough, because schools of medicine and surgery found that their demand for human corpses far exceeded legitimate supply, making it necessary to obtain bodies from other sources.

It was not unusual for medical students and lecturers to clamber over churchyard walls to obtain corpses; but as the practice of obtaining bodies became more and more hazardous, it was safer and easier for them to pay others to obtain recently deceased cadavers with no questions asked.

This encouraged the activities of those familiarly known as body snatchers, grave robbers or resurrection men. When the general public learnt of this, there was a

Ye Olde Dolphin Inn.

public outcry. Not only did medical practitioners involved in dissection run the risk of unpopularity among a public who preferred not to consider how valuable medical knowledge was obtained, but medical men were also attacked and many surgeon's premises were burned to the ground (see also Froggatt Edge).

The abovementioned Derby physician must have run that risk as it is highly likely that the cellar of his house was used as a temporary morgue and a place to carry out anatomical research and dissection. Distasteful though the subject is, it has given us the following amusing story.

One night, two men arrived on the doctor's doorstep with a body trussed in a sack.

'Take it down the cellar,' the doctor said, then paid the men, who headed speedily back to the local tavern. The doctor went down to examine his purchase and found that the body was not dead, only dead drunk. The following night, 'the body' shared the fee with his pals in yet another drunken spree.

Is it surprising that staff at Ye Olde Dolphin Inn believe that some residual energy from that time has stayed in the cellars?

The Cavalier at the Old Silk Mill Public House

The ghost of a Cavalier is said to haunt the Old Silk Mill public house on Full Street at the junction with Sowter Road, so is there some connection between this spirit and the brief visit of one of the most famous Cavaliers of the age, the dashing young Charles

Above left: The Old Silk Mill.

Above right: The sign at the Old Silk Mill, where the ghost of a Cavalier is said to linger.

Edward Stuart, better known as Bonnie Prince Charlie? Could this spirit Cavalier have been billeted here during 1745 when the Prince was leading the Jacobite Rebellion on its march to London in an attempt to re-establish the Stuart dynasty? Derby must have been swamped with Charles's supporters. Lisa Roper, who owned the Silk Mill, told me how she had flipped when she was told of her spirit visitor. She was none too happy finding that her property housed a ghost. 'I never saw anything, but there was no way I would stay there alone after that,' she admitted.

Having a ghostly Cavalier is a very fitting and poignant reminder that this is the furthest point south that Charles Edward Stuart got in his march south in December 1745. He stayed at Exeter House in Full Street, home of the Earl of Exeter, on the nights of 4 and 5 December 1745, and it was there in the drawing room that heated discussions took place. Charles wanted to continue the march south but his officers wanted to retreat. Eventually, in desperation, Charles had to accept the latter course of action. Charles's dream of taking the crown from George II would be finally crushed at the Battle of Culloden in 1746 (see also Hartington Hall).

The Caring Maid at the Old Bell Hotel

Derby's location at almost the centre of the country made it an important coaching location. In the 1700s, there were thirty-six horse-drawn stagecoaches thundering through the little streets of Derby each day; and to service these coaches, eighteen coaching inns sprang up around the centre. Built about 1675, the best-preserved example today is the Old Bell Hotel in Sadler Gate. It was a favourite spot for highwaymen watching out for wealthy travellers who they could later rob in the quiet country lanes.

The building is haunted by many ghosts, including a grey lady who walks about the place and a poltergeist that throws things around behind the bar. But the most famous is the ghost in Room 29, reputedly a serving wench who was murdered by Bonnie Prince Charlie's soldiers in 1745, although there is nothing to substantiate the story.

In the 1920s, Room 29 was the bedroom of the landlord's son, who was an asthmatic. In the middle of the night, his parents woke to hear him coughing and retching, so they hurried through to his room. He was standing in the dark by his bed, bent forward, and a young girl, wearing an eighteenth-century costume complete with starched apron and mob cap, was standing over him patting his back to try to relieve his anguish. As the parents entered, the girl disappeared.

In the 1950s, Room 29 was used as a nursery. The landlady at the time was changing her baby's nappy in there. She turned away for an instant and, as she turned back to the baby, saw a serving wench who was about to pick up her child. The mother screamed and lunged forward to grab the baby, lifting it through the apparition. Although she could still see it, she felt neither drop in temperature or rush of air.

In 1971, Ann Jones was working as a secretary at the Bell Inn. It was 3 p.m. and the inn was closed, but two police officers who had just had lunch, the chef, the manager Nick Fay and several members of staff had gathered in the lounge for a drink and a chat. The chef's Boxer dog had also been brought in and Ann suddenly saw the dog's hair stand on end.

Above left: The Old Bell Hotel.

Above right: The ghost at the Old Bell Hotel seemed to come through a closed door from this cobbled alleyway.

'His fur looked just like a hedgehog,' Ann recalled. She suddenly felt a tremendous chill and, as everyone stared in disbelief, a grey figure appeared. It seemed to come through a closed door from the cobbled alleyway, crossed the lounge, then passed through the locked door that led to the mews and outbuildings. All those present saw the figure and Dolly Millwards the barmaid, white with shock, gave everyone a much-needed whisky.

Goings-on at the George Inn

Almost opposite The Bell is a narrow alleyway between the shops. This is George Alley where the coaches trundled through to the rear of the George Inn, built around 1693 and one of the most famous coaching inns in Derby. George Alley runs parallel to Sadler Gate and comes out almost at the end opposite the museum and art gallery. It's probably due to the authenticity of the place and the cobblestones that are very hard on the soles of the feet, but it's easy (if you ignore the double yellow lines) to imagine you've travelled back in time along George Alley. That's probably why people have reported sounds of phantom laughing and joking, and horses whinnying and stamping their hooves as if in readiness to get off on the next stage of their journey.

The George, which has also been known as Lafferty's Pub and Jorrocks, was not only a coaching inn; it also provided a place for courts, council meetings and recruitment

offices. Doctors, dentists and vets held surgeries here and, when necessary, it served as a post office and a morgue.

It was also a place where a gentleman could stay if he didn't own a town house. Many gentlemen certainly did stay at the George Inn, including the Duke of Devonshire, and during the 1745 uprising it was used as the Jacobite headquarters. Could it be one of these gentlemen that has stayed in spirit? Dressed in a blue coat, a ghostly figure with sharp features and very long hair has been seen walking up and down the stairs, sitting in the bar area and lurking on the landing at the top of the stairs. Items get moved and he gets blamed, yet nothing is ever broken and it's usually put back.

But he doesn't appear to be alone because no self-respecting gentleman of the eighteenth or nineteenth century would have been found in the kitchen, which is where staff complain their things get messed about and moved.

The George has many ghosts and mysteries, none more bizarre than the George skull. This female human skull with a damaged cranium was found by workmen 4 feet down beneath the cellar floor – with it were other bones, fifteen animal skulls, and strips of leather. The reason for these burials has never been made clear. Some say these were items thrown into a midden or refuse pit. Another possibility is that the site on the corner of Sadler Gate and Iron Gate was a former Viking leather worker's shop and the animal bones and skulls were from the animals killed for the leather market. It's possible that either explanation could be correct, but neither would reveal why a human skull was among the discovered items.

The old George Inn, also called Jorrocks.

After the discovery, the poltergeist activity started. Chunky glass pint pots in the hands of female staff shattered so regularly that they were tested to see if it was a faulty batch caused by some malfunction in the manufacturing. It wasn't. It was suggested that the shattering was caused by glasses reacting to the cold after being in too hot a dishwasher, yet the glasses always shattered before being put in the dishwasher, not after. There's also poltergeist activity in the basement where the skull was found; one barman had a stainless steel bucket thrown at him. Furthermore, the telephones and intercom system often work on their own; BT can find no explanation, but is apparently not unused to such occurrences.

The skull is now on display in the bar like some form of macabre artefact or talisman, and if you touch it – depending upon whom you believe – you can have either good or bad luck.

Trapdoor Findings at the Tiger Inn

It was inevitable that when the railways came to Derby, the coaching inns lost most of their trade. Many disappeared or were converted into shops, while others became vastly reduced in size. The Tiger Inn was one of the latter. It stood at the corner of Corn Market and Market Place, and was served by Tiger's Yard. The old stables of the inn is now the site of the current Tiger Inn, and Tiger's Yard is now known as Lock-Up Yard – it was given the name because of the police station that was built where the fish market now stands. This is where, on 12 July 1879, a young policeman named Joseph Moss was murdered by a drunk called Gerald Mannering.

When the lock-up was pulled down, nine warehouses were built for the use of the market traders. Mr John Bolton, a florist in the market hall, had No. 3 built over the spot where PC Moss was shot. One day he was working in the warehouse, making a wreath, when he felt an icy blast as if someone had opened a freezer door. He also had the rather unnerving feeling that someone was watching him. Turning round slowly, he saw a policeman wearing a rather strange-looking helmet. John Bolton described him as having a handlebar moustache and looking so real that he thought the man must be one of the bobbies that used to stand on point duty at the bottom of Lock-Up Yard. He hadn't heard the door open to admit his visitor and he threw a quick glance at the closed door before turning back to his visitor, who he saw was slowly melting away.

There are a series of tunnels underneath the Lock-Up Yard area, one going directly from what were the cells to the assizes court at the guildhall. Many people have reported hearing the sound of trudging feet along these tunnels, a throwback to those earlier days when prisoners would have passed through on their way to be sentenced to execution, transportation or imprisonment.

In 1972, when part of the Tiger Inn at the corner of Corn Market and Market Place was being knocked down, an Irish workman clearing away rubble uncovered a trapdoor. When he lifted it he could see straight down into a cellar, and there on the floor sat a young boy, about six years old, wearing Victorian clothes. Concerned that the child had fallen into the hole, the man asked him what he was doing there and the child replied 'I live here' before promptly disappearing. The workman and his mates, concerned for

Derby

The fish market in Lock-Up Yard, previously the yard to the Tiger Inn.

The ghosts of frightened prisoners haunt the tunnels under the Tiger Inn.

the safety of the child, made a thorough investigation but found nothing. The child had simply vanished. They informed the *Derby Evening Telegraph*, one of whose reporters – who was pictured peering down the hole – wrote a lengthy article about the ghost.

Spooky Voices at Ye Olde Spa Inn

Around 1773, a Dr Chauncey came across a mineral spring just off Abbey Street in Derby. Chauncey was an entrepreneur and envisaged Derby being a spa town to rival places like Buxton and Bath. Simpson's *History of Derby* records the following:

> He put down a basin into the spring of it, to come out fresh: he built a cover over the spring which discharges itself by a grate and keeps the place always dry. About 20 yards below the spa, he made a handsome sold bath and some rooms to it at considerable expense.

Apparently Chauncey was only exploiting something that was already well known. In 1611, the burgesses of Derby were already receiving rent for a 'watering place on the edge of Abbie Barne', so it appears that the commercial properties of the spring had been appreciated for at least 120 years before Chauncey decided to capitalise on them. When Dr Chauncey died in 1736, his spa seems to have died with him. A double-gable cottage that became a farm was built on the site, and in the nineteenth century it became the public house that stands there today.

Appropriately called Ye Olde Spa Inn, the building appears to be haunted, but whether it's by the ghost of Dr Chauncey or someone else, no one seems to know. On frequent occasions the landlord has sensed that he is not alone in the cellars, and he and the staff regularly hear their names called by someone who simply isn't there.

In the 1970s it was run by Gill Mayall, who admits that, although she never saw anything herself, curious things happened – thumping noises and sounds of things being thrown about, particularly in the cellar.

Paranormal Hunters at the Old Barley Mow

The Old Barley Mow on Osmaston Road was probably built in the 1850s as two separate houses. There is some speculation that one was originally a shoemaker's before being turned into the Old Barley Mow Public House. Buildings with character often raise for us the question of whether or not they are haunted, and after the landlord heard whispering and saw a shadow glide across from the pool room towards the back of the bar and the cellar, he decided to find out by contacting the Derwent Paranormal Group.

During the group's first evening investigation in 2002, a dictaphone left on in the pool room recorded various anomalies. When the tape is played back at a higher speed, there is a strange whining noise. But it could have picked up outside traffic or the electric fan in the cellar, and although they tried to replicate the sound, they were unsuccessful.

At about 4.15 a.m. one of the team took a number of photographs of the bar; on one of them, behind the landlady, can be clearly seen a bare arm wearing a short-sleeved T-shirt. Everyone was huddled up in coats and jackets as all-night vigils can be very cold. No one was wearing a short-sleeved T-shirt.

On their second visit, the team set up two remote thermometers: one in the pool room and the other in the cellar. The pool room thermometer remained at a constant temperature of 19.8 degrees Centigrade, but the cellar thermometer showed a strange fluctuation ranging from an almost constant 10.7 degrees to a sudden rise to 14.6 at 2.24 a.m. It remained at 14.6 degrees for ten minutes then returned to 11 degrees. No explanation for this could be provided.

Motion detection cameras ran for most of the night, purportedly capturing a ball of light manifesting on the left side of the picture before it dropped and disappeared. The team also caught the usual dust anomalies on their night-spot cameras. Various sounds were recorded in the cellar, but on analysis they seemed to be more mechanical than paranormal and, as at least twelve people were moving around in the room above, they were discounted.

Clairvoyantly, the team felt that the pool room spirit was similar in personality to the late owner of the pub, so perhaps a later investigation can reveal a bit more about the ghosts of the Old Barley Mow. It's certainly an interesting prospect because there definitely seems to be some paranormal activity there.

Shady Dealings at the Noah's Ark

In the seventeenth century, a man called Noah Bullock built himself an 'ark' and moored it on the River Derwent near the Morledge. It's unlikely that he lived there in such cramped conditions with his wife and nine children, but he certainly used the vessel as his business premises. The problem was that Noah's business was illegal. He was running an unregistered mint. Not only did he make counterfeit money in his floating ark, he was also known to clip a few silver coins. This was in the days when a silver coin was worth its weight; but by clipping off a small amount and combining it with other clippings, an unscrupulous person could literally make money. Inevitably, in 1676, his crimes caught up with him. Yet, alas, this Noah's ark didn't offer the protection or shelter of its predecessor and couldn't save Noah Bullock when he felt the long arm of the law. Noah appeared before the Recorder of Derby, Sir Simon Degge, whom Noah knew well. So, to save himself from the hangman's noose, Noah promised to end his activities, broke up his ark and sank it in the Derwent.

Today, the Noah's Ark Pub on Morledge gets its name from Noah Bullock, who is said to haunt the place along with other equally disreputable characters, including a girl who seems to be watching out for someone. Is she keeping watch for Noah Bullock in order to warn him if the authorities were approaching? If you should see Noah, it is said to be a lucky omen as it means money will be coming your way. But don't spend it in advance, because others say the opposite: if you see Noah, you will soon be parted from your money.

DRONFIELD

Dronfield is an expanding and progressive township situated in the north-east of Derbyshire, halfway between Sheffield and Chesterfield. It possesses an interesting blend of old and modern buildings. Many of the old and listed buildings are in the old centre of Dronfield that clusters around the church, and it's here that you will find four of the most haunted pubs in the area.

Spectres at the Blue Stoops

The Blue Stoops was built in the 1590s and has two 1596 date stones, one on the front of the building and the other over the fireplace in the right-hand bar to confirm it. It was originally known as the Blue Posts, but that is not so different since 'stoops' are marker stones placed at crossroads to guide travellers along the old packhorse routes. The inn sign that existed at the end of the nineteenth century showed two stoops or bollards, but the maker of the current sign has clearly put his own interpretation on the name stoop or stoup, which is a small basin for holy water.

Although the Blue Stoops has changed little over the years, Mr Street recalled how it was when his grandfather was the landlord from 1882 to 1907. Beer was priced at eight pints for a shilling, and gin was 2½ pence per glass. He remembered the women customers who would smoke their long clay pipes, as well as the ghost of a young girl who used to walk around the ground floor. There's no record as to who she was, but it was said that she was illegitimate and supposedly murdered there.

On 1 April 1980, there was a fire and the place needed completely redecorating. Since then, the ghost of the little girl has never been seen again, although occasionally a glass falls off a shelf for no obvious reason. In August 1993, one of the regular customers died. A day or two before his funeral, another regular was walking past the Blue Stoops on his way to work. It was 5.30 a.m. and there was a light on in the bar; so, prompted by curiosity, he stopped and peered through the window. A man was standing by the bar and it was not Tony Singleton, the landlord: it was his dead drinking companion.

The Ghostly Matron at the Manor House Hotel

The original Manor House at Dronfield was built in 1540. When it was replaced (by the building that is now the library) it was divided to form four separate cottages, Nos 10–14 High Street. The cottages were made into a hotel in the 1960s, then reopened in January 2009 as a privately owned, independent contemporary hotel. It is in the part which was once No. 10 that visitors and staff have experienced various

Above: The Blue Stoops, Dronfield.

Right: The Blue Stoops' sign.

The Manor House Hotel.

The Green Dragon.

ghostly phenomena and sensed the friendly presence of an old lady who is believed to have lived at No. 10 at the turn of the last century. She is described as being seventy years old, wearing long skirts with lace-up boots, and having tied-back hair.

Customers have not only seen this figure; they have also seen the movement of brass ornaments, heard the rattle of pots and pans, been touched fleetingly and on occasions felt the old lady clinging to their arms. There is so much activity, yet the idea of calling in an exorcist is out of the question. Everyone who has experienced the hauntings feel she is a friendly spirit. The lady obviously likes the place and the company and doesn't want to leave. So next time you visit the Manor House Hotel, be prepared to encounter the friendly spirit of one of their regulars.

Chantry Priests at the Green Dragon and Chantry Hotel

The Green Dragon was originally the hall of the chantry priests and headquarters of the Guild of the Blessed Virgin Mary, established in 1349. It probably became an inn after the dissolution of the monasteries in 1547.

Up to this time, both the Green Dragon and what is now the Chantry Hotel were buildings used by the chantry priests associated with the church of St John the Baptist opposite. Both the inn and the hotel are probably developments of the same medieval building. In the bar of the inn there is a medieval arch in the party wall and the two buildings are linked by a passage, so it's not surprising to find that they also share a paranormal spirit or two. Although all the gas cylinder taps are very stiff, on occasions they have been interfered with and even turned off. According to the landlord of the Green Man, this ghost has a very definite taste for certain types of beer. Both real ale and keg beer is served, but while the cask beer remains unmolested, the others are regularly tampered with.

At the Chantry Hotel, lights are switched on and off and the fridge plug is often pulled out. More destructively, glasses from the Welsh dresser have flown across the room and plates have mysteriously smashed, but thankfully no one has been hurt by these flying missiles.

EARL STERNDALE

The Silent Woman at Earl Sterndale

Earl Sterndale is a limestone village on the western edge of Derbyshire, a mile from the infant River Dove. Its lack of picturesque qualities has meant it has not been invaded by tourists and the most notable feature is the Quiet Woman pub and the rather macabre story behind the name.

 According to the legend, the landlady talked incessantly. She squabbled and bickered with the regulars, rowed with her neighbours and constantly found fault with her husband. The years passed and the long-suffering husband suddenly flipped: in a moment of insanity he decapitated her; but instead of him being tried for murder, the villagers sided with the landlord and he was acquitted. His action had brought peace and quiet back into his and their lives, so the pub was renamed, and a sign showing a headless woman was hung with the inscription 'Soft Words Turneth Away Wrath'. That must surely be the reason this place is said to be haunted by a headless woman.

The Quiet Woman.

EDALE

Airmen at the Old Nag's Head

The Old Nag's Head at Edale is the official starting point of the 270 mile Pennine Way, and as might be expected from a pub that dates back to 1577, there is a lot of spirit activity. For a long time, people have been seeing mystery aircraft plunging down on these moors and there have been fruitless searches for them. Sometimes there are numerous witnesses whose testimonies tally. Some of these witnesses are no-nonsense farmers who admit that the mist-shrouded Peakland hills have a means of tapping into some kind of memory field because, since the end of the First World War, the tragic history of plane crashes has continued with fifty planes in as many years mysteriously coming down over this stretch of bleak moorland.

In these instances, the bodies of the airmen were brought down to the Old Nag's Head, which served as a temporary morgue, and this is where their spirits still remain. Several customers have reported seeing ghostly figures in airmen's uniforms, and there have been unidentifiable sounds and eerie voices heard around the pub.

The Old Nag's Head.

EYAM

The Miners Arms – The Most Haunted Building in Eyam

Eyam is a secluded Peak District village tragically famous as the 'plague village'. The year 1665 saw outbreaks of plague in London and many other towns and cities across England; but when it arrived in Eyam the villagers chose to lock themselves away in isolation in order to prevent the plague spreading. This was an act of true altruism by grief-stricken villagers and now, every year, thousands of people flock to Eyam to pay their own respects to those courageous villagers.

Understandably, the village inns are a major draw, and the most popular is the Miners Arms, built during the early seventeenth century, about twenty years before the deadly plague struck the village. It has been described as a building with atmosphere and has also been labelled the most haunted building in Eyam. That's no mean claim in a village where almost every cottage has a resident ghost.

When living at the Miners Arms, Mr and Mrs Hall stated that they had heard footsteps walking along the bedroom corridor, and the sound was always accompanied by the rustle of a woman's skirts. The Halls' fourteen-year-old daughter Wendy was terrified when she felt an unseen intruder in her bedroom leaning over her bed.

When Mr and Mrs Peter Cooke took over the licence, they'd only spent two nights on the premises when, due to a power failure, they had to retire to bed by candlelight. As they lay in bed they could hear loud, firm footsteps in the corridor outside their bedroom, but they knew this was no human intruder because the footsteps were on floorboards, not deadened by the soft pile of the carpet. When the door handle began to move and they felt a definite presence, the landlord searched the room with a candle but found nothing.

That bedroom landing was always persistently cold – even when extra heating was used to try to warm the air – and the bulb in the light socket at the end of the landing fused on a regular basis for no obvious reason. Even more strange was the fact that whenever the footsteps were heard, next morning the door of a cupboard off the landing was always found open. This occurred so regularly, even after the cupboard had been carefully secured, that in the end they covered it with hardboard and papered it over.

On another occasion, Mr Cooke woke in the small hours of the morning to hear a phantom clock being wound by spirit hands. His daughter's record player would begin to play when no one was in the room and, while with a companion, Peter distinctly heard his name being called. The companion verified this.

After the Miners Arms underwent a complete revamp, Mr J. A. Carnall, chairman of Eyam parish council, reported having seen an elderly lady wearing elastic-sided boots, a black bonnet, and a cape trimmed with jet sequins, enter the back door of the

inn. Both the lady and her attire belonged to an earlier generation and, according to Mr Carnall, she appeared to be confused and bewildered by the structural alterations made to the property. Probably not half as confused and bewildered as Mr Carnall when the lady evaporated before his eyes.

According to local legend, this lady is the seventeenth-century wife of a former landlord who died after falling or being thrown down the stairs. Is it she who wanders along that upstairs corridor? Are the heavy footsteps that defy the softening effect of the carpet those of her murdering husband? And did he try to hide her body in that cupboard where the door mysteriously refused to stay closed?

It's not surprising that the Miners Arms proved to be very active when investigated by a paranormal group called Strange But True. According to secretary Yvonne Gregory, there is much activity in the passages, and a return visit is planned.

The Miners Arms – the most haunted building in Eyam.

Cockeye and the Golden Ball Inn

The Golden Ball Inn that used to stand at the Stoney Middleton side of Eyam Dale was much frequented by the local miners. At the time of this story, it was kept by a man called Stephen and his French-born wife, Blandino, known to everyone as Blandy. She was an agreeable woman, but had perfected the art of mining the miners by plying them with drink for however long they had money in their pockets.

Tom Loxley, known to everyone as Cockeye, was a regular at the Golden Ball Inn and, although frequently worse for drink, was always in good humour and popular with everyone. It was late one evening when his mates were ready to leave that they began to torment Cockeye, reminding him of the dark journey he faced alone through Eyam Dale past the ruins of what was known locally as the haunted cottage. The locals shunned it by day and avoided it at all cost by night because in this crumbling, ivy-clad hovel they believed there lurked a malevolent ghost who was often seen on moonlit nights flitting across the valley at great speed.

'Come on, Tom,' laughed Blandy. 'Take another drink to rally your spirits. Surely you are not afraid of a woman, dead or alive?'

The other miners laughed and Cockeye naturally rose to the bait and declared, 'No, nor the devil himself. Pour me another drink, Blandy.'

Stephen the landlord was not comfortable with such talk. He was firmly of the belief that if you call the devil he will come in his own time.

Cockeye set off from the Golden Ball Inn full of confidence and bravado, vowing to face any ghost that might lurk in the lonely dale. He was in a jocular mood when he left the warmth and comfort of the lamp-lit room of the inn to make somewhat unsteady progress up the dale towards his home. As he proceeded along the moonlit way, tree shadows assumed fantastic shapes and the babble of the wayside brook suggested to the drunken miner that he was surrounded by ghostly voices engaged in excited conversation of which he was the subject. Loxley's courage was now rapidly slipping away and he began to regret some of the comments he'd made, especially as he approached the old ruined cottage and imagined the ghostly tenant leaving the shadows and approaching him in angry confrontation. His drunken imagination seemed to see in the shadows a twisted human form that moved and writhed towards him. He stood transfixed, too terrified to go on, too frightened to turn back in case the thing should rise up and pursue him. As his senses began to reel, the poor fellow staggered and with a choking groan his legs gave way and he fell face down in the dirt. Shaking uncontrollably, he felt his ankles gripped by icy hands as he was dragged at a fast pace down the dell. As the grip tightened and the coldness increased, he lost consciousness.

It was warmer, gentler hands that gripped and shook Cockeye awake in the morning. Stephen, the pub landlord, had found him half in and half out of the stream that winds through the dale. Its icy waters had nearly frozen him to death.

There were some that said that it was all conjured up by Cockeye's drink-sodden mind, that the icy grip of the ghost was the water of the stream he had fallen into. But no one could convince Cockeye of that. He stuck to his story for the rest of his life and never touched another alcoholic drink.

FROGGAT EDGE

The Trade of the Body Snatchers at the Chequers Inn

The Chequers Inn at Froggat Edge certainly has a chequered history. Originally, the building was six cottages dating from as early as 1591. In 1632 several of these cottages were converted into an alehouse on the old packhorse route, and later it became a coaching inn on the Hathersage–Sheffield turnpike. According to the landlord, one or two old-timers appear to have lingered on, including the occasional Roman soldier and a few former regulars who practised the rather seedy business of body snatching.

Froggatt Edge, with its long escarpment that can be seen for miles, makes for an ideal lookout point – and its isolated position made the Chequers Inn ideal for those wishing to trade in stolen bodies. In the eighteenth and early nineteenth centuries, schools of medicine and surgery found that their demand for human corpses, on which to practise anatomical research and dissection, far exceeded legitimate supply; as a result, the skills of British surgeons lagged behind those in France and Germany. So to expand their knowledge they needed to obtain bodies from other sources. Initially it was not unusual for medical students and lecturers to clamber over churchyard walls to obtain fresh corpses; but as the practice of obtaining bodies became more and more hazardous, it became safer and easier for them to pay others to obtain recently deceased cadavers with no questions asked. Medical practitioners involved in dissection ran the risk of unpopularity among a public who preferred not to consider how valuable medical knowledge was obtained, so the 'business' went underground.

During the nineteenth century, body snatching or grave robbing became a flourishing business and those involved were dubbed resurrection men, stiff lifters or sack-'em-up men. At first, a body could be had for £2, but the price eventually rose as high as £20, which brought out the most undesirable element: determined men who could make more money for one night's work than a month of honest toil.

In 1779, when William Hallam took over as landlord of the Chequers Inn, he was willing to turn a blind eye to the activities of the stiff lifters, so the inn acquired a reputation as a popular haunt for body snatchers. There are tales of cadavers being left outside in carts while deals were done over a mug of ale inside. And although it's not a nice subject, some amusing stories have survived. For example, a doctor and his assistant, having conducted their business at the Chequers Inn, left their 'passenger' huddled on a seat in their horse and trap. The ostler, a friendly kind of guy, tried to engage the person in conversation, but when he gave her a gentle nudge, she slumped helplessly forward, revealing the features of a corpse.

On another such occasion, a corpse was left propped in a trap outside the pub while two resurrection men called to do a bit of business. Several locals, aware of what was taking place, decided to play a practical joke on the stiff lifters and removed the

The Chequers Inn, 1903.

The Chequers Inn today.

corpse. One of the locals climbed into the trap in its place and shortly afterward the resurrection men climbed back into the vehicle. On a particularly bumpy stretch of road, the one sitting by the side of the 'corpse' reached over to steady it.

'It's warm,' he shrieked with a gasp of horror.

'Yes and so would you be if you'd been where I have,' came the sepulchral reply. The two men were so terrified that they leapt from the trap and disappeared. The abandoned horse and trap were never claimed and were later sold by the jokers, who divided the proceeds between them.

The trade of the body snatchers flourished and the law did nothing to stop it because, in the eyes of the law, there was no property in a dead body, so it could not be stolen. Taking clothes would make the crime into a felony, while stealing a body was merely a misdemeanour! On the other hand, if a ring or the shroud was taken with the body, the thieves could be severely punished; so in order to avoid this and flaunt the stupidity of the law, the resurrectionists would dig up a body, drag it from the grave, strip it of the shroud and any other possessions, bundle it in a sack and trundle it away. If time permitted, the shroud would be returned to the coffin, which would then be covered again to conceal the clandestine activities.

Most Members of Parliament were reluctant to pass legislation to make more bodies available for the training of surgeons because that would almost certainly lead to public outcry. Instead they turned a blind eye to the way surgeons obtained their bodies. The

A 'corpse' surprises a body snatcher.

masses, however, were not so accommodating. Sometimes there were riots, homes and hospitals were ransacked, medical men were attacked, and many surgeons' premises were burned to the ground.

Public awareness caused the city body snatchers to look further afield in search of easier pickings, and lonely country districts like Derbyshire were ideal. People feared that their dead bodies might end up in the hands of the surgeon, so many churchyards were locked at night and broken glass was set on the tops of graveyard walls. Guns operated by tripwire were mounted over bodies and explosives were planted in the graves. Some deceased were buried in metal coffins with multiple locks. Stakes were driven through so that the lid could not be raised and heavy iron gratings or sets of bars known as mort safes were secured over new graves. Relatives and friends of the deceased sat up for a week after the funeral, keeping watch, armed with blunderbusses and cutlasses until decomposition had begun to make the body useless for medical purposes.

It probably took the notoriety of two men involved in body snatching to eventually bring an end to all of this. William Burke was an Irish immigrant who worked in partnership with William Hare, and they plied their trade in Edinburgh around the beginning of the nineteenth century, supplying corpses to the anatomist Robert Knox. They began to get rather greedy and lazy and, rather than robbing graves, they found it far easier to secure a ready supply of bodies by killing people themselves.

Body snatching eventually came to an end with the passing of the Anatomy Act (1832) which stated that anyone wishing to practise anatomy had to be licensed by the government. The Act also stated that the bodies of men and women who died in hospitals and workhouses and were not claimed within 72 hours could be sold for dissection. This assured the surgeons a supply of bodies at a much lower price – and the trade in stolen bodies died (excuse the pun). (See also Ye Old Dolphin Inn, Derby, and The Royal Oak Inn, Ashbourne.)

GREAT HUCKLOW

Great Hucklow is a hamlet set in beautiful surroundings on the hills between Tideswell and Eyam. At its heart is the seventeenth-century Queen Anne Inn, a typically old-style, child-friendly country inn, which dates back to 1621. It's haunted by a previous landlord who apparently died in the cellar.

Queen Anne Inn. (*Courtesy of Garstonian*)

HARDWICK

Faceless Monk in Hardwick Park

Bess of Hardwick is the stuff of legends and is undoubtedly the greatest of all the Elizabethan dynasts. She is responsible for two of our great country houses, Chatsworth House and Hardwick Hall, which is perched on a ridge above the valley of the M1 motorway.

In 1959 Hardwick Hall, with 1,000 acres of adjacent park and woodland, was acquired by the National Trust. The grounds were converted into a Country Park during the 1970s with the provision of footpaths, facilities for angling, and the building of a modest visitor centre. It has become a popular tourist destination, but beware: the grounds are haunted. Fortunately, at the southern entrance is the Hardwick Inn, where it might be advisable to obtain some Dutch courage.

On 4 January 1976, eighteen-year-old Mark Gresswell and his fiancée Carol were driving through the grounds of Hardwick Hall when Carol suddenly let out a shriek of disbelief. She was sure she had just seen a ghost. She described it as wearing monk's clothing and having a brilliant white face. Mark stopped the car, then manoeuvred it round, using the headlights to illuminate the area. While doing this, another car passed and Mark then saw what he described as 'a big, tall and broad chappy' with an almost luminous face and wearing monastic garb. It came towards them, then turned and disappeared into the night. Mark again tried to sweep the area with the car headlights but saw nothing.

They drove away and at the gates of the Hardwick Park pulled into the car park of the Hardwick Inn. They told their story to the landlady, who confirmed that the same figure had been seen twice in the previous five days. Shortly afterwards, the couple in the car that had passed them arrived and confirmed their story. They too had seen the monk.

Dot Brunt, a National Trust employee who lived at nearby Stainsby, saw the monk on three separate occasions. He's been seen by several estate workers, two police officers and two other witnesses from Sutton in Ashfield. In fact, his appearances were so numerous they were often reported in the *Derbyshire Times*.

Built in 1608, Hardwick Inn replaced an earlier inn on the site kept in the 1570s by a husbandman called Robert Tomson, a tenant of James Hardwick who paid an annual rent of 8 shillings for a 'tenement at the park gates' and certain land in Hardstoft. The present inn was built by John Ballechouse, known as John the Painter, a highly regarded craftsman who worked on Hardwick Hall. He designed and built the inn as his own residence. It was taxed for eight hearths in 1662, so it was impressive, spacious and certainly comfortable by the standards of the time. Throughout the seventeenth and eighteenth centuries, upper servants from the Hall lived at the inn, which had eight

chambers upstairs. It must be one of the few pubs that has had a book written about it. It is a fascinating place and Pamela Kettle's *A History of Hardwick Inn* will give you all the details. According to the landlord, only eight families have lived here in its 400 years.

Hardwick Inn.

HARTINGTON

The Spirits at Charles Cotton Hotel

There can't be a more scenic centre for exploring the upper reaches of the Dove than Hartington, and the scenery, especially the fine limestone hills that flank the river, attracts large numbers of people annually. The place is world-famous for its cheeses, particularly the Hartington Blue Stilton, and for trout fishing, the latter made famous by Charles Cotton, so it's not too surprising to find the Charles Cotton Hotel on the edge of the village square. Hartington was an important market centre in the middle ages, hence the large village square where the stone-cased water pump still operates, a survivor from the days before piped water came to the village.

The Charles Cotton Hotel was built as a coaching inn named the Bull's Head in the late seventeenth century. During the eighteenth century it was acquired by the Sleigh family and renamed the Sleigh Arms. They extended it to its current size in 1864 and obviously did a sympathetic job because, in 1870, it was described as a quiet, old-fashioned country inn. By 1905, it had changed its name to the Charles Cotton Hotel, named after the local squire, who has been described as a 'prince of anglers'. He was born in 1630 at Beresford Hall, just one mile from the hotel, and although his family home is now a ruin, the name lives on in Beresford Dale. A few yards from the Charles Cotton Hotel, an easy footpath leads into the dale.

Charles Cotton's status, however, comes not from being the local squire but from being co-author with Izaac Walton of that genial seventeenth-century classic *The Complete Angler*, the first guide to fly-fishing. As a talented writer and poet, his works remained in print until the 1930s, but sadly this did not earn him enough to support the lifestyle of a country gentleman and he was constantly plagued with money problems. The fishing temple that the friends shared is still to be seen despite being on private land, and the reputation of the River Dove for trout fishing attracts millions of anglers annually.

According to the *Haunted Hotels Guide*, the Charles Cotton Hotel is also haunted. Although reports are slight, there's one from a lady who stayed in the hotel in 2004 with her husband and two daughters. They all slept in the one room, which had a bathroom en suite. During the night, her husband got up to use the bathroom. He had what she described as a horrid feeling as he walked through the doorway between the bedroom and bathroom. Next morning, the younger daughter revealed that she had spent the night hiding under the bedclothes as she had seen a lady in a long nightie, carrying a candle, walk through the wall by the doorway to the bathroom.

Judy Dyer, the new proprietor of the Charles Cotton Hotel, knew nothing about this report but did confirm that she had been told the hotel has spirit activity. Judy is

According to Judy, Charles Cotton haunts the hotel that bears his name.

sensitive to spirit energy and said, 'Sometimes I feel a presence. It appears there is a young spirit that floats around, then there is Charlie himself.'

The Ghost of the Heartbroken Maid at Hartington Hall

Hartington Hall is a fine sixteenth-century manor house, one of the first properties to be acquired by the Youth Hostel Association and opened in 1934. Situated in this delightful spot, it's not surprising to find that it's a very popular place, and the restaurant and bar are open to non-residents.

The ghostly tale that is associated with Hartington Hall is one of long standing and originates from 3 December 1745, when HRH Prince Charles Edward Stuart, better known as Bonnie Prince Charlie – accompanied by a bodyguard of Scottish lords, the music of bagpipes and an army of 7,000 – crossed the county border from Staffordshire to Derbyshire. The Prince was leading the Jacobite Rebellion on its march to London in an attempt to re-establish the Stuart dynasty. Ladies were eager to catch a glimpse of His Royal Highness who, at twenty-four, was described as 6 feet tall with a majestic presence; yet the undisciplined band of soldiers evoked both fear and pity.

The River Dove would have been used as a navigational aid, and Hartington's position at the crossing of the Dove gave it strategic importance. It is therefore not unreasonable

Hartington Hall.

The Bonnie Prince Charlie Room at Hartington Hall.

to assume that the Prince was invited to share the hospitality of Hartington Hall but enjoyed more than just the usual generosity of the house. A certain bonny young maid caught his eye and, since she was a loyal supporter, his wish was her command. The Prince stayed the night in what is now known as the Bonnie Prince Charlie Room, and as he rode away the next day he promised to return for the maid once the political upheavals had died down.

He moved on to Derby, where he stayed at Exeter House on the nights of 4 and 5 December, and it was there in the drawing room that heated discussions took place. Charles wanted to continue the march south but his officers wanted to retreat. Eventually, in desperation, Charles had to accept defeat and abandon this attempt to take the crown from George II (see the Old Silk Mill, Derby).

On 6 December, the whole army turned round and began sullenly to retrace its steps. The Prince is reported to have stayed at Ashbourne Hall with Major General Sir William Boothby on the first night of his retreat; by the following night he would have been out of Derbyshire. As history tells us, the following April the Jacobite army was massacred at Culloden. Prince Charles escaped to the Isle of Skye with the help of Flora Macdonald and from there he sailed to France and ended his life a disappointed man living in perpetual drunken exile.

Sadly he never did return to Hartington Hall and the inconsolable maid died of a broken heart. But even then she kept up her vigil. Visitors to Hartington Hall have reported seeing her ghost wandering from room to room, peering at the sleeping occupants, apparently looking for her prince.

The heartbroken maid keeps her lonely vigil waiting for her prince. Is that her face at the window?

HASSOP

Eyre Arms and Hassop Hall Hotel – Cavalier and Carriage

Hassop, which lies between Bakewell and Calver, is an attractive mixture of farms and cottages, and there are many stories told about the stretch of road that passes through the hamlet. It could be the most haunted road in Derbyshire. One gentleman who regularly travelled on this route said that, as he passed Hassop Hall Lodge and former Dower House, he was often aware of the scent of honeysuckle. Pleasant though this was, it was rather disturbing to smell such a scent in midwinter.

A Sheffield man was driving home from Bakewell one night. He was driving slowly to negotiate several bends in the road near Hassop Hall Hotel when suddenly there was a blinding flash and his car engine just stopped. He sat for a few minutes quite dazed, then tried restarting the engine, but it appeared to be quite dead. In frustration he opened the car door and was met by an icy blast of cold air. He shivered as he went round to release the bonnet catch and peer at the engine. There was no smoke or smell of burning that might have explained the flash, so he closed the bonnet and got back into the car. The engine started up immediately and he drove on rather warily.

A few minutes later he was passing the Eyre Arms and noticed a policeman riding a cycle ahead of him. He decided to enquire if the patrolling officer had seen anything unusual, but the policeman turned right into the narrow Wheatlands Lane. The driver deciding it was not that urgent, and proceeded on his way to Calver. Some time later, he met the police officer who patrolled the area and decided to mention the incident. The officer stared at him in surprise. Police officers no longer rode around on bicycles: they carried out their patrol duties in panda cars.

Don't be surprised if you encounter the phantom Cavalier who steps out into the road in front of vehicles, or the phantom coach and horses that is likely to overtake you. Many motorists who have encountered them suffer from shock, and apparently one died after swerving to avoid crashing into a coach and horses crossing his path. Traumatised people who have witnessed these strange phenomena call in at the Eyre Arms in Hassop to tell their stories, which all bear a striking similarity. What few realise is that the Cavalier also haunts the Eyre Arms, where he has appeared to customers and staff.

Hassop Hall Hotel is hidden away behind a tall garden wall skirting this road. It's now a very popular country house hotel, but the recorded history of Hassop reaches back 900 years to when it was the principal residence of the Foljambes, who remained until the end of the fourteenth century. At the close of the fifteenth century, Hassop came into the ownership of the Eyre family, until in 1852 Francis Eyre, the 8th Earl of Newburgh, died unmarried. The estate then passed to his sister, who was also childless and on her death it became the property of her widower, Colonel Charles Leslie. He

A phantom coach travels along this stretch of road past the Eyre Arms. It has also been seen at Hassop Hall.

may have inherited the estate but not the title and this became a contested affair. Having passed through several family ownerships, the hall was converted into a hotel in 1975.

Although there is every likelihood that it is haunted, there are no actual reports of any spirit activity in the hall. However, there have been sightings of that phantom coach. Early one morning, a guest staying at Hassop Hall Hotel looked out of his bedroom window and saw a coach and horses being driven along the drive. It looked so impressive that when the guest went down for breakfast he asked the receptionist if it was possible to book the coach for a nostalgic drive around the area. The receptionist looked puzzled. It is possible to book a period coach for such an event, but after making a thorough check the guest was informed that no such coach had called at Hassop Hall that morning.

HATHERSAGE

The Talk at the Scotman's Pack Raised Little John from His Grave

The Scotsman's Pack on School Lane, Hathersage, stands on one of the old trackways leading to Sheffield. It was a regular calling place for the travelling drapers or packmen from Scotland who visited every farm and village in the area offering their goods – hence the name. The present building dates from 1900, although traces of a much older building have been found. But could there have been a building here when Little John, the friend and lieutenant of Robin Hood, frequented the area? It's reputed that Little John came from Hathersage and returned here to die and be buried in the churchyard on the hillside. As the Scotsman's Pack is just below the graveyard, does Little John haunt the area? He does if you read the framed poem that is hanging above an oversized chair that is said to have belonged to Little John. The poem is called 'Little John's Grave':

> The Scotsman's Pack was full that night
> The talk flowed fast and free
> And wondrous tales were brought to light
> By all that company
>
> A sun-burnt hiker told the tale
> Oh how mid ice and snow
> And shrouding fog and driving hail
> Cross Kinder he did go
>
> Another told how all alone
> He'd gone down Eldon Hole
> And come up close to Bolsterstone
> Or else at Stanage Pole
>
> An aged man did then relate
> How on the stroke of ten
> A ghost hopped o'er the churchyard gate
> And walked the world again
>
> ''Twas Little John himself' said he
> And then began to chime
> The hour of ten. Regretfully
> The landlord shouted 'Time'

The lights were dimmed and then arose a figure strange I ween
Full seven feet high from head to toes and dressed in Lincoln Green

He spoke in deep sepulchral tones 'My name is Little John;
Beneath these yews they laid my bones, my life on earth is gone

A big stone at my head and feet, I sleep in earthly bed
But the lies you fellows told to-neet are enough to wake the dead.

Gadzooks, i'faith, and by my soul, my slumbers you did break
I could draw the long-bow well myself, but you chaps take the cake.'

And with these words he floated out before their very eyes
So tipplers mind what you're about and in your tales be wise

And as you drink the spirits down and your spirits start to soar
Beware lest all the yarns you spin bring spirits back once more.

The Scotsman's Pack, Hathersage, where Little John's ghost appeared to the tipplers.

The ghost of Florence Nightingale haunts the Jug and Glass.

The former village hospital in Lea, where Florence Nightingale nursed the sick, is now the Jug and Glass.

LEA

Florence Nightingale Haunts the Jug and Glass

The Nightingale family first brought prosperity to the area of Lea and Holloway after Peter Nightingale amassed a considerable fortune from lead mining in 1707. He bought Lea Hall and became lord of the manor and, along with his son, established a successful lead-smelting business at Lea Bridge, one of the largest lead-smelting works in Derbyshire. By the end of the eighteenth century, all the lead from Derbyshire mines was smelted here. Having established a hat factory, which also employed 100 people, the Nightingales were the largest employer in the area, but they were also caring employers and provided a hospital for their workers. This is probably where Florence Nightingale's interest in nursing began since after her father had inherited this great wealth, Florence, the future 'lady with the lamp', who brought nursing out of the dark ages and made it a serious and respected profession, spent most of her childhood days at the little cottage hospital.

She was very young when she first realised that she had a calling to help people, starting with the local villagers who suffered from malnutrition, disease, poverty and poor sanitation. She persuaded her parents to provide her with the goods she needed to help the sick and she spent a lot of time at the little hospital, where she distributed food and medicine and tended the sick. This was a start, but she soon realised her limitations. To become more proficient, Florence was determined to gain valuable nursing experience, but her family were horrified and refused to acknowledge her wishes.

Florence secured the position of superintendent at the London Institute for the Care of Sick Gentlewomen, then in August 1853 she left Lea and, using her own money and contacts, on 21 October 1854 she travelled with forty nurses to the Scutari Barracks in the Crimea to nurse the sick and dying soldiers. Her contribution made nursing a respectable profession and history has remembered her as 'the lady with the lamp'.

The small cottage hospital at Lea, originally part of a row of workers' cottages dating from 1782, is now the Jug and Glass and there is definitely a spirit presence there. Could it be Florence Nightingale? Someone is responsible for the sighs, the creaking floorboards, the strange antiseptic smells and the sudden, inexplicable drops in temperature. Many people believe that it's the caring spirit of Florence Nightingale who still wanders round her familiar haunts in Lea and the old cottage hospital where she had her first experience of nursing the sick.

LONGSHAW ESTATE

Phantoms at Fox House

Fox House lies on the main A625 road between Sheffield and Hathersage on the edge of the Longshaw Estate, the former shooting domain of the Duke of Rutland on the eastern edge of the Peak District National Park, on the Derbyshire/South Yorkshire border.

Its rural isolation might suggest that the name came from the animal, but it's actually from George Fox of Callow Farm, who built Fox House in around 1773 as a shepherd's cottage. The middle section of the inn you see today is the oldest and contains the remains of that earlier shepherd's cottage. The house was acquired by the Duke of Rutland around 1849, when a lounge was added with rooms above and cellars below. At this time, it was called the Traveller's Rest. *A Stranger's Guide to Sheffield*, published in 1852, featured the inn, which was then kept by Mr Tomas Furness, and stated that 'for attention and good accommodation there is no better house on the road'. There is a legend that there's a tunnel from the cellars of the inn to the lodge on the Longshaw Estate, a Grade II listed building built in 1827 as a shooting lodge for the dukes of Rutland. Whether this was to prevent the Duke being seen nipping off for a quick pint, or getting wet and dishevelled doing so, is unsure.

Among the guests who have stayed at the lodge were George V and the Duke of Wellington. The 1,600-acre estate was sold and broken up in 1931 and has been in the hands of the National Trust since the early 1970s.

Fox House has another rather obscure claim to fame: it is thought to have been the model for White Cross in Charlotte Brontë's *Jane Eyre*. Charlotte Brontë stayed with her friend Ellen Nussey at the vicarage in Hathersage during the summer of 1845, and her visits to North Lees Hall on the outskirts of Hathersage fired Charlotte's fertile imagination and inspired her fictitious Thornfield Hall, the home of Mr Edward Rochester where Jane Eyre became governess. Even the name has been adopted from North Lees: 'thorn' is an anagram of 'north', and 'field' is derived from 'lee', a medieval word for pasture. Charlotte's name for her heroine was taken directly from the residents of North Lees Hall at the time of her visit, the Eyres. Hathersage became Morton, the name of the landlord of the George Hotel in Hathersage; Brookfield Manor became Vale Hall; and Moorseats became Moor House, home of the Rivers family.

In the story, when Jane left Thornfield, she only had enough money to get her as far as White Cross, where the coachman put her down in the middle of wild, inhospitable moorland. It's easy to see how its rather isolated position above the village of Hathersage inspired Charlotte Brontë.

The public bar of Fox House was added in 1895, and in 1927 the Carter, Milner & Bird brewery – now defunct – bought it from the Duke. There are no reports of

Fox House, Longshaw Estate.

hauntings until the Hayes family moved in in 1973; but once they began to relate such things, a customer born in 1908, whose family looked after the inn for forty years, said they used to have similar experiences. Strange noises were heard every morning, while voices carrying on conversations are heard in empty rooms.

A faceless monk is known to walk through the bar. In recent years there have been seen the ghosts of a child, a woman, and a headless body. Once, all the tubes in a sunbed shattered and there was absolutely no reason for such a thing to happen. A glass flew across the kitchen as if thrown by an invisible hand. In the bedroom known as the ghost's room there is a feeling of an unseen presence – one lady guest found all the buttons on her boots had been undone by ghostly hands.

MAKENEY

The Holly Bush Inn: The Haunt of Dick Turpin

The highwayman is often portrayed as a romantic figure attired in fancy clothes, an aristocrat among thieves who just happens to be down on his luck. This dashing young gentleman would ride around the country righting wrongs and stealing nothing from a pretty maid but a kiss. That's the romantic image and the mystique that surrounds the highwayman owes much to his supposed chivalry, his gallantry to ladies, his illicit affairs and his numerous narrow escapes. The highwayman became a popular folk hero, especially among the poor who had nothing to fear from such a person as they seldom travelled and, more importantly, had nothing worth stealing.

The archetypal highwayman was born in the aftermath of the Civil War when the execution of Charles I in 1649 left many Royalist officers without any means of support. Because they were unaccustomed to earning a living and had no trade to fall back on, they took to the high road.

According to the 1890 *Ward's Almanac*, Dick Turpin, probably the most notorious highwayman of all, was born in Horsley, Essex – but could it have been Horsley in Derbyshire, hardly two miles from Makeney? Many people believe that it was and that this is Dick Turpin country. The area is certainly rich in Turpin folklore.

There are many Turpins living in the area and even more in the graveyard. Dick is reputed to have stayed at a cottage next to Horsley church as well as a farmhouse opposite the Coach and Horses Inn, but it is not possible to find a direct family link.

Considering his lifestyle, inns were an integral part of Turpin's life on the road. It is not surprising that several establishments along his old routes claim to have enjoyed his custom. In 1722, the death penalty was imposed for being armed and disguised on high roads and open heaths, but after an arrest it was not just the death penalty that was carried out: gibbeting the corpse was popular right up until the mid-nineteenth century (see also Wardlow Mires).

Dick Turpin was hanged at York on 7 April 1739, but the ghost of the intrepid Dick still haunts many old roads and wayside inns. At the 300-year-old Holly Bush Inn at Makeney, just inside the hall, a newspaper cutting is displayed which asks for Turpin's body to be returned to Derbyshire.

His body may be missing but his spirit is active. He has been seen astride a galloping Black Bess on the Chevin, standing at the crossroads on the old Belper to Ashbourne road, sitting in a tree at Duffield and pacing up and down outside the Holly Bush Inn at Makeney.

Above: The Holly Bush at Makeney, the haunt of Dick Turpin.

Right: The ghost of the intrepid Dick Turpin has been seen all around the area.

MATLOCK BATH

A Roman at Hodgkinson's Hotel, and Albert at the Princess Victoria

Matlock Bath has a long history that goes back to the time of the Romans, who extracted lead from the local hills. Lead mining continued sporadically through the centuries, then, stimulated by the demand during the sixteenth and seventeenth centuries, it expanded to become a major industry in the limestone country of Derbyshire. During the second half of the nineteenth century, when richer and cheaper lead reserves were found elsewhere, Derbyshire lead mining went into sharp decline, but by then Matlock Bath had reinvented itself. It became a fashionable spa town where the well-to-do built grand villas, and the name 'Bath' became significant. In this spectacular setting, wealthy Victorians sampled the medicinal waters that were rich in mineral deposits, and enjoyed Matlock Bath's promenade atmosphere and the surrounding scenery. The air was said to be very healthy and the caves, the pleasure gardens and other natural phenomena all helped to provide a complete holiday. The rich and famous – including the young Victoria prior to her becoming queen – mingled in this picturesque spa town whose growth was hindered by its relatively poor transport system.

The naming of the Princess Victoria pub on South Parade is a nice touch, but there is no record of the pub ever receiving the young princess, who visited Matlock Bath in 1832 before she became queen. However, the Princess Victoria pub does have a resident ghost. Who it is remains a mystery, but would you believe they call him Albert, the name of the Prince Consort?

When a road was opened up from Cromford and the railways reached Matlock Bath in 1848, the place positively leapt to overnight prominence. Crowds flocked in and the 'quality' moved out. Its natural beauty was boosted by commercialism, and with a wide range of visitor attractions it soon developed into an all-round inland resort. Understandably, visitors needed places to stay, and right in the centre of the South Parade is Hodgkinson's Hotel. Although built in 1698 and extended in 1770, it acquired its name when bought by Job Hodgkinson in the 1830s, and from there he developed a substantial business as a purveyor of wines and spirits. The north part of the hotel was his old brewery, using as his cellars the caves or old lead mines that go deep into the hillside.

In the mid-1980s the hotel was jointly owned by Nigel Shelley and Malcolm Archer, and they began to realise that they had not only bought a hotel, but had inherited a ghost. Light bulbs that had been firmly fixed in ceiling fitments would fall onto the wooden floors but never break. In fact they would be replaced and work perfectly. Doors constantly closed with a bang, footsteps were heard, and the handle on the front door was often seen to move down as if someone was about to open the door and enter the hotel. People often said that they had been suddenly overpowered by an icy-cold

feeling, especially at the back of the hotel in the area of the caves. In September 1986, an archaeologist was staying at the hotel and his experiences led to a medium being called in. The medium felt drawn to the caves and ancient lead mines that run behind the hotel, so he was taken there by Nigel Shelley.

The medium asked for all the lights to be turned off, including the high-beam lights that illuminated the caves. As soon as these were off, the medium ran into the depths of the cave and, according to Mr Shelley, the next thing he felt was a breeze blowing down the cave. 'I could hear the medium talking to someone,' he said. 'And what was even more surprising, I could hear someone answering. When the medium finally came back, he informed us that it was the ghost of a Roman soldier that had been causing the phenomena. He was there, the medium said, to guard a jewel-encrusted sword which centuries ago he had hidden in the caves. The medium also went on to explain that the strange happenings had taken place because the soldier's ghost often passed through the hotel checking that everything was in order, and occasionally, if he felt in the mood, he played games with whoever happened to be there.'

After the medium's visit, the strange things ceased to happen and things returned to normal.

Hodgkinson's Hotel, haunt of a Roman soldier.

MIDDLETON BY WIRKSWORTH

There's a report that a young girl haunts the Rising Sun at Middleton by Wirksworth. In the 1950s, when the landlord was undertaking some building work he came across a secret bedroom boarded up. Whether the girl had been trapped there or imprisoned is unsure, but there is evidence that she could have died in the boarded-up room.

The Rising Sun, Middleton by Wirksworth.

MILLER'S DALE

Roguish Roger at the Angler's Rest

The hamlet of Miller's Dale has been home to at least one mill for the last 900 years. In the *Domesday Book* of 1088 one mill was recorded, yet this part of the River Wye once powered many mills along its 20-mile (33-km) course. There were textile mills and timber sawmills, bobbin mills making the spools for the textile industry, a mill to saw and polish marble, and even one that made combs from cow horns.

By the end of the nineteenth century, watermills were no longer able to compete with larger steam or electrically powered roller mills, and the last mill at Miller's Dale closed in the 1920s. Now the area is a tranquil paradise frequented by walkers and anglers so it's rather appropriate that the local inn, which dates from 1753, is called the Angler's Rest. It also appears to have a resident ghost.

Beryl, Graham and Ian Yates moved into the Angler's Rest seven years ago, and although Beryl often suspected something slightly unusual, she wasn't sure until one day when she was vacuuming the hikers' bar. When the vacuum cleaner suddenly stopped, Beryl couldn't understand what was wrong until she checked the plug and found it was half out of the socket and switched off. The vacuum cleaner had a long length of flex. It was not caught and there was no way that she could have pulled it, so the incident remained a mystery until she went to visit a Buxton medium with a few friends.

Much to her surprise, the medium told Beryl that she was being shadowed by a man named Roger, and he was there with her. The medium asked Roger why he was shadowing Beryl and he said it was because he liked her. The medium asked if he had a message for Beryl and he replied, 'Tell her to keep wearing the stockings.'

Above: The Angler's Rest at Miller's Dale, haunted by Roger.

Left: The ghost sent a message via a medium telling Beryl to keep wearing the stockings.

MOSBOROUGH

Royal Connections and Bloodstains at Mosborough Hall

Derbyshire had a number of royal connections during the Tudor period. The best-known is that between Queen Elizabeth and Arbella Stuart, the beautiful, ill-fated daughter of Elizabeth Cavendish and Charles Stuart. Arbella was considered by many, including her grandmother Bess of Hardwick, to be the rightful heiress to the throne of England. She was on a par with her cousin King James of Scotland, but it was he who took the English crown on the death of Queen Elizabeth. A closer link is between Queen Elizabeth and her cousin Henry Carey, Lord Hunsden. His mother was Mary Boleyn, sister of Anne Boleyn, Elizabeth's mother. Mary Boleyn married William Carey after having an affair with Henry VIII, and within a short time she produced a son they named Henry. Court gossip was rife as to the boy's paternity and it was widely acknowledged that he was Henry VIII's son. But then the King's lustful eye focused on Mary's younger sister, Anne, and the rest, as they say, is history.

Apparently in recognition of the part Henry Carey played in quashing the Babington plot to free the imprisoned Mary, Queen of Scots, from Wingfield Manor, the grateful Queen Elizabeth gave him the lordship of Eckington and Mosborough, and made him a Knight of the Garter.

His home, Mosborough Hall, in the village of the same name, sits right on the Derbyshire/Yorkshire border, between Chesterfield and Sheffield. The name was originally Moresburgh, meaning fort on the moor, and it is mentioned in the *Domesday Book*. Part of the present hall dates from the fourteenth century, although the fine Georgian portion was built in 1625 with a later façade added. The hall fell into disrepair during the last century but has since been converted into a luxury hotel.

It was during the renovation work that five blocked-up tunnels were found, which led from Mosborough Hall to Eckington Hall, 600 yards away. The entrance to one of the blocked tunnels is still outlined in the old staircase hall. Sam Beecher, architect for the conversion, said that while working on the project he often felt odd vibrations and heard unexplained noises. He admitted to feeling nervous when staying there alone overnight, so he took his dog Seco with him for company – but Seco wouldn't go beyond one area of the first floor.

During the conversion, old floorboards were replaced in what is now bedroom No. 9, the bridal suite. The reason for this was to remove what looked surprisingly like bloodstains on the floor, because no matter how hard the area was scrubbed, the attempt was unsuccessful.

How these stains came to be there – and trailing up the staircase – relates back to a local tale of how, in 1692, a serving wench was made pregnant by the local squire. But when she confronted him in the lane, he refused to accept responsibility. The girl

Mosborough Hall.

threatened to tell his wife and ran across Hollow Lane and back to the hall. He chased after her, caught her, pulled out a knife and murdered her in that upstairs room.

Since then there have been many sightings of the poor girl's wraith; she has been observed running from the farmyard, across Hollow Lane, and through a doorway that was used by servants when they collected eggs or milk from the farm opposite. All the sightings are around the eighth day of September.

During the 1914–18 war, a small detachment of officers and men of the old Nottinghamshire and Derbyshire Regiment was billet at Mosborough Hall, and one room that overlooked Hollow Lane was occupied by a young soldier named Peter Andrews. His first night passed without incident, but on his second he was roused by the sound of voices under his window. A man and woman were having a fierce argument which so disturbed him that he got out of bed and peered through the window, but the lane was deserted. Thinking they must have moved on quickly, he thought nothing more of this until the following night when he and a few friends were in his room playing cards after official lights-out. Suddenly they all stopped and listened as angry voices were heard outside in the lane. They all peered out of the window but saw nothing, then the room went icy cold and from the corner of the room by the door came a deep sob of anguish. Nothing could be seen, but the sobbing moved across the room to the window where, pausing, it seemed to reach even deeper depths of despair. As the fascinated men watched, a pale, cold light seemed to emanate

from the area of the sobbing, and, as the light painted the recognisable shape of a young woman, the terrified men rushed for the door and stumbled out of the room as fast as they could. They garbled out an almost unintelligible version of their fright to a group of fire-pickets, who surprisingly showed no disbelief. They too had heard the quarrel as they stood by the doorway to Hallow Lane. The words had been very clear. The girl addressed the man as both 'James' and 'Sir'. She was pleading with him, then she threatened to tell his wife, at which point the figure of a young woman ran through the door towards one of the fire-pickets. He instinctively held out his arms to prevent a sure collision, but the impact didn't come – that unhappy form was not of earthly substance.

Peter Andrews had made up his mind that he was not staying another night in that room, so the next day he related the story to Sergeant McGranaghan, a tough old soldier who was disinclined to believe a word of it. However, after having a word with the others, he decided to seek the advice of Dr Pilcher, a Mosborough GP from 1908 to 1922 who also served as the Medical Officer for the Mosborough detachment. He was a no-nonsense man and, although he had heard the stories, he convinced the sergeant that it was a highly unlikely tale – and to prove it he'd sleep in the room that night. This caused quite a stir, and not only at the hall: as word spread to the local pubs, speculation of the outcome led to bets being placed.

The doctor and the captain carried out a thorough inspection of the room, and after having a chat with the boys and a nightcap with the captain, the doctor retired around 10.30 p.m. He was woken by the captain's batman knocking on the door at 7.00 a.m. with a cup of tea. The doctor unlocked the door, but as the batman entered he froze on the spot. The bed was stained and dripping with the unmistakable redness of blood, which formed a pool on the polished floorboards. Within a minute the doctor was reduced to a whimpering wreck and had to be helped down the stairs and driven home. He resigned his post as medical officer and never set foot in Mosborough Hall again.

This story came from a woman who was in service with Dr Pilcher at the time, but there are many other locals who will tell you equally fascinating tales.

The nephew of a local pub landlord took his dog for a walk along Hollow Lane. He was a tough young man in his twenties, but when he returned he was shaking like a leaf. He said he had heard a couple arguing and, as he walked on down the lane, a girl ran out of the farmyard and disappeared in front of him. Two local women witnessed a white swirling mist on what is known as The Brow by Mosborough Hall Farm. Late in the evening of 9 September 1978, Bernard and Elsie Spense were walking in the lane. They had never heard of the ghost, so stood aside as a young woman in a white dress glided silently by, then disappeared. But not all the supernatural activity is outside. Many strange noises and voices are heard round that doorway where the fire-picket had his experience. Recently, on at least two occasions, staff working in that area have heard their names called.

In 1981, an American was conducted to the room assigned to him – the notorious number 9. He had never heard of the ghost of Mosborough Hall, but he stood on the threshold of the room with its sixteenth-century four-poster bed and oak wall-panelling. 'I'm not sleeping here,' he informed his guide. 'There's something here. You have a ghost, haven't you?'

The ghostly Room 9.

Without knowing its history, other guests have reported feeling strange vibrations in this room, but probably the most bizarre incident concerns a couple who were celebrating their honeymoon in this suite. They recorded a video on which they claimed were a number of distinctive orbs, but the tactful staff were too diplomatic to ask to see the video to check this out for themselves.

Country Pursuits at the The Crofts Public House

The Crofts opened in the late 1980s, yet within days the staff were being bombarded with tales of a spectral horse that seemed to appear in the car park. Customers were suddenly forced to brake and swerve in order to avoid colliding with these apparitions which simply vanished into thin air. Staff and customers were totally mystified when several other customers reported that a pony and trap had appeared in front of them as they entered the car park.

The management understandably began to get rather alarmed that such a situation was likely to cause a serious accident. They decided to investigate what could be causing this, and they found that The Crofts had been built on the site of a former farmhouse, dating back to 1707, and in the corner of a neighbouring field was a pond that apparently had been used as a watering hole for the farm horses. At the

end of a working day, the horses would be driven down to the pond where they could take a drink, and apparently these spectral horses were still taking their evening trip, undeterred by the fact that the car park had been constructed across the old route to the pond. In a desperate attempt to stop these spirit steeds, the landlord had the pond filled in, but getting rid of ghosts isn't quite that easy.

The Mossbrook: Where Three Friends Felt a Child Running Past

Three ladies who live and work in Eckington make a habit of going to The Mossbrook every Friday night for a drink after work and to unwind for the weekend. They are familiar with the place, but on one recent occasion, while sitting in the bar, two of the ladies experienced the sensation of a child running past them. The third lady felt nothing, but the other two compared notes and their descriptions were uncannily similar.

The Mossbrook.

NORTH WINGFIELD

The Spirits at the Parkhouse Hotel

The manor called Winnefelt in the *Domesday Book*, along with neighbouring manors, were given by William the Conqueror to one of his followers, Walter de Ayncourt. With their name anglicised to Deincourt, the family had a mansion called Park Hall between North Wingfield and Pilsley, which remained in their possession until the extinction of the male line in 1422. It was a bit of a mystery where the ancient home of the Deincourt family was, until in 1867 the Clay Cross Coal & Iron Company sunk their No. 7 shaft at what became known as Park House Colliery (1867–1962). Thick foundations were met and passed through, and there was much evidence to show the existence of an ancient building. The roughly flagged pavement of what appeared to be a cellar floor was exposed. And when a thick slice of the western face of the hill was cut away, further portions of foundations or cellar walls were unearthed along with bones, fragments of pottery, hatchet heads and axes.

In 'A Norman Manor House' (*Derbyshire Archaeological Society Journal*, vol. 40), George Griffin wrote: 'Little does the Parkhouse collier realise today that during the first eighteen feet to his descent, he is in fact passing through the cellars of a Norman Baron.'

The colliery was considered, like all the Clay Cross Company pits, a model of its day; yet on 7 November 1882, there was a huge explosion. Horrendously burnt or poisoned by the inhalation of afterdamp, forty-five men and boys – some as young as fifteen – lost their lives. Throughout the rescue operation, the bodies were conveyed to the Queen's Head public house – now the Parkhouse Hotel. The dead were laid out in what is now the pool room. So as might be expected from a place used as a temporary morgue, there is plenty of spirit activity.

Several people told me about the ghostly lady who glides through the rooms and has been witnessed by previous landlords. Could she have been administering to those poor men or was she a distraught wife brought to the place to identify the bodies of her husband or sons lost in the tragedy? Pete, the present manager, hasn't seen her, but he has seen the old man who walks around the pool room. Apparently he's been seen by many people and he's always described as being accompanied by his faithful dog.

The Parkhouse Hotel was originally four cottages that have been changed considerably over the years. Pete believes that this apparition dates back to a time when the pool room was part of a separate cottage, presumably lived in by the old man and his dog, who return in spirit to their old home.

Above left: The Parkhouse Hotel was originally four cottages. The old man that haunts the building is believed to have been a former resident.

Above right: The pool room served as a temporary morgue after the Parkhouse pit disaster.

The Blue Bell Inn

Next to the church in North Wingfield is the Blue Bell Inn, which dates from the fifteenth century and was formerly a chantry house. It's hard to believe this building dates back 600 years because many of its ancient features have been destroyed by modernisation, and yet it still retains its ghosts. There's a short-haired black dog that haunts the beamed bar. When Diane Watts, the current licensee, first saw it she was so convinced it was genuine that when it disappeared she got down on her hands and knees to search for it under the tables and chairs. When she could find no trace, she questioned whether she had in fact seen the resident cat and mistakenly thought it was a dog – but she found the cat fast asleep upstairs on the bed.

There's also the blue lady who makes regular, fleeting trips through the lounge and the adjoining living accommodation. Her materialisations are both amazing and theatrical as she appears enigmatically from the centre of a blue haze.

It is generally accepted that the ghostly blue lady is the heiress of a Vernon, and who married John Savage, son of Sir John. He was killed at the battle of Boulogne but apparently the poor lady continues to wait for his return.

She is what is known as a cyclic ghost, governed by the forces of nature. She has a distinct aversion to the cold and only appears in the warmer weather. Paranormal signs always announce her arrival: the lights flicker and dim, bottles and glasses mysteriously disappear, then appear again.

Diane confirmed that she has seen the figure of a woman in the entrance area and at one side of the bar. She has also felt a sensation as though hands were being placed on her waist from behind. Apparently the ghost also has a playful nature and can be rather mischievous, so she sounds like rather good company to find in a pub.

OAKERTHORPE

White Monks Haunt The Peacock at Oakerthorpe

The Peacock at Oakerthorpe, which sits on an old Roman road, is reputed to be Derbyshire's oldest inn, with parts dating back to the eleventh century. The name Oakerthorpe – or Ulgurthorpe, as the early settlement was called – is a Viking name. Thorpe means an outlying farm and Ulgur or Oaker was the original settlement owner, thus Oakerthorpe. It is referred to in the *Domesday Book* as having a monastic establishment administered by White Monks, and it's highly possible that The Peacock was part of this monastic establishment and that White Monks were the earliest inhabitants of the building.

This fact is verified by the network of tunnels underneath The Peacock, apparently dug out by the White Monks in the 1400s for the extraction of coal or lead. With only primitive tools, it was a hazardous, backbreaking job; cave-ins were a regular occurrence and it is said that several monks were crushed to death and left to rot in these passages. Do they haunt them still? Could that be why the ghost of a White Monk is regularly seen here? Several people have reported seeing him hovering above the ground and some have described him as being faceless.

If you don't encounter the genuine faceless monk, look for the glass panel set in the floor in the entrance lounge. Down below in this illuminated section of one of the tunnels, there's a skeleton propped against the wall. Is this the fate that befell our faceless monk?

It is said that one tunnel leads all the way to Wingfield Manor, but what large house in the area doesn't make a similar claim? So far no one has gone far enough along these tunnels to find out. Because they flood on a regular basis, they are described as wet, smelly and downright unpleasant. A visit is not to be undertaken by the fainthearted as enclosed spaces, particularly those reputedly haunted by a White Monk, are rather unnerving – to say the least.

After being rebuilt in 1613, The Peacock became a commercial coaching inn due to its position at the junction of what were three turnpike roads. During its heyday in the eighteenth century it had stabling for seventy-two horses with sixteen coaches changing horses there daily.

According to legend, near the blacksmith's forge at the rear of the premises there was once a secret underground stable that local horse thieves used. Apparently Dick Turpin also used the stable to hide Black Bess while he spent his time in the inn in conversation with the more wealthy, well-dressed travellers using the inn's facilities while passing through the area. Having determined who was likely to be carrying the most lucrative hoard, he could then select his next victim.

The stable has now been filled in and covered over by the car park, but the ghost of the intrepid Dick still reputedly haunts the place. Could he be searching for a flintlock pistol which he allegedly dropped while making his escape astride his faithful Black Bess? Until the 1950s, when it mysteriously disappeared, the pistol was displayed at The Peacock.

The Peacock.

A skeleton in the cellar of The Peacock.

OLD WHITTINGTON

Hatching a Plot at the Cock and Pynot

Whithington, Witintune, and now Whittington is from the Old English 'ton' or 'tun', meaning farm. In this case, three Anglican farmsteads grew into the independent villages of Old Whittington, New Whittington and Whittington Moor.

Combining the three, Whittington is a suburb of Chesterfield, 160 miles north of London, yet it has several little-known connections with the capital. Firstly, it gives us one of our best-known historical figures: Sir Richard of the family de Whittington. Many people think of Dick Whittington as a pantomime character, but he was actually the youngest son of the lord of the manor, Sir William Whittington, and his wife Joan. Because Dick inherited neither title nor wealth, he made his way to London, where he had heard that the streets were paved with gold. The ballads and pantomimes weave fact with fiction, but Dick did make his fortune in London and was three times mayor. Not bad for a guy from Whittington.

Our second connection is with a property now known as the Old Revolution House. This charming thatched cottage was a former inn called the Cock and Pynot ('pynot' is a Derbyshire word for magpie). It dates back to the seventeenth century, when farmhouses also doubled as alehouses, but what makes this one special was that in June 1688 four noblemen met here to devise a scheme to dethrone James II, who had ascended the throne upon the death of his brother, Charles II, in 1685. The plotters planned to invite his nephew, the Protestant Prince William of Orange, who also happened to be married to James' daughter Mary, to become King of England.

This decision followed a turbulent three-year period during which James II demonstrated his adherence to the Roman Catholic faith and, with the help of the infamous tyrant Judge Jeffreys and his Bloody Assizes, persecuted thousands of Protestants. This and the King's many broken promises caused unrest all over the country, but in this little out-of-the-way inn at Whittington a revolution was devised by the four brave noblemen: William Cavendish, 4th Earl of Devonshire (great, great grandson of Bess of Hardwick and given the title 1st Duke of Devonshire for his part in the plot); Thomas Osbourne, Earl of Damby; John Darcy, grandson and heir of the Earl of Holderness; and Henry Booth Baron Delamere. According to tradition, William Cavendish led the discussion while sitting in a chair in what has become known as the Plotting Parlour. The original chair is now on view in Hardwick Hall, but there is a copy at the Revolution House. The chair is especially significant as it was probably the only one in the place. People sat on forms or stools – a chair was for the chairman, a term we still use for the person who heads a meeting or company.

The plot became known as the Glorious Revolution as it was virtually bloodless. Prince William set sail for England. He was joined by his wife Mary and together they

The Cock and Pynot alehouse is now the Old Revolution House.

were proclaimed King and Queen of Great Britain and Ireland.

The Cock and Pynot remained an alehouse for the next century, but it was in a poor state of repair after another hundred years. In 1938 it was taken over by the borough council and is now part of the Chesterfield Museum. Furnished as it would have been in those far-off days, it has retained its charm – but it has also retained its ghosts. Many people have sensed a presence in the building. It's described as rather shadowy, although they stress it is not threatening. There are sudden cold draughts and a strong smell of old leather in the ground-floor room, and voices that sound like farmers arguing over the price of cattle. Some have seen a face peering through the small leaded window. One lady, while looking out of the window, felt a tug on her cardigan as if it were being pulled by a demanding child. She turned to see who it was, but she was alone. Others have seen a dog wandering through the room and some have felt it brush past their legs, but all agree that the atmosphere at the Revolution House is calm and welcoming.

OWLER BAR

The White Lady, Headless Man and Monks at the Peacock Inn

Owler Bar lies just inside the north Derbyshire border and could be described as one of the bleakest spots in the area, standing as it does 1,010 feet above sea level. The word 'Owler' comes from the alder tree, which would indicate that the inn was once surrounded by trees; now it is just surrounded by moorland. It lies on the A621 Sheffield to Baslow road at its elongated roundabout with the A6051 to Barlow, the B6054 to Holmsfield and to the Longshaw Estate. It's always been an important road junction and coaching stop, and a toll bar cottage has stood at the road junction near the Peacock Inn from about 1816–18; it served a turnpike road that was built in 1781.

The 'old' toll bar was at Wragg's farmstead, before the 'new' toll bar and cottage was built. This cottage changes hands quite frequently and could be because of the peculiar, though often implausible, tales that are told. One owner got up in the middle of the night to go to the toilet and, when he returned to bed, he found a little old lady dressed in a Victorian nightgown sleeping in his bed. He turned off the lights then turned them back on again, but she was still there. I'm not sure what we have here: is it a spook or a spoof? Things might become apparent when you've had a few drinks at The Peacock!

The Peacock is a fine old coaching inn, but the original inn dates from the early sixteenth century, slightly forward of the present building, which was constructed in 1848 by the Duke of Devonshire. Built of millstone grit, it retains its old-world charm with oak beams and low ceilings, and also preserves its ghosts.

In the twenty years that Alice and Antonio Fernandes ran The Peacock, they regularly saw the ghost of the white lady who haunts the building. Judy, the barmaid, has also seen her behind the bar and described her as in her early twenties and very beautiful, dressed in a white shroud which showed only her face. Who she is remains a mystery, as does the identity of a headless man who has been seen by the chef in the dining room. The chef also saw a man in a long frock coat in the car park in front of the pub and round the back. Five monks have also been seen walking in single file across the field.

POMEROY

William Pomeroy Haunts the Duke of York

Pomeroy is a hamlet situated on the A515 Ashbourne–Buxton road south-west of Flagg on the edge of Flagg Moor. Flagg is renowned for its annual point-to-point races, a rare event that reflects the early days of horse racing when riders rode from one point to another – the points being the tips of the church steeples of two neighbouring parishes with no defined course between. A few years ago, there were many of these old-fashioned races, but now Flagg is the only one in the county, and it is run over Flagg Moor with the field boundaries providing the jumps.

This is natural hunting country, so I was hoping to find a definite link between these races and the tragic riding accident of a local man named William Pomeroy who now haunts the Duke of York at Pomeroy. This is a well-proportioned country pub in the beautiful setting of the White Peak overlooking the Derbyshire Dales. But when everyday things go missing and the kettle switches on despite no one being around, staff blame the ghost of William Pomeroy.

Jenny and the Old Man at the Bull i' the Thorn

Just a kilometre down the A615 can be found reputedly the oldest inn in the county, the Bull i' the Thorn. A dwelling has been on this site since 1472. It has been an inn since the 1660s, and it is very spiritually active.

In many haunted places, people can sense that something is going on but can offer nothing more tangible than a gut feeling. The Bull i' the Thorne is different; Annette the landlady believes several ghosts haunt the place but are happy to be there. She regularly senses that she is not alone in the pub and can recount many paranormal experiences – like pictures, plates and mirrors falling off walls – as well as the strange sensation of having her hair touched when apparently no one else is in the room. Although she has never actually seen a ghost, others have.

The pub can boast of having what is described as a dead man's chair, which apparently came from

The ghost of a little girl named Jenny haunts the Bull i' the Thorn.

Chatsworth House and belonged to William Cavendish, Earl of Devonshire. How it got there is a mystery; but, now cordoned off to preserve it, the chair is said to be a favourite place of the ghost of an old man.

A medium was called in and made contact with the spirit of a little girl who claimed to have died during the Great Plague in the 1600s. Her parents apparently died when she was quite small, which is why she sits there waiting patiently for them to return. Apparently her favourite place is on the slipper box.

Annette says Jenny can be a naughty little girl as she takes things. Pub staff report putting cutlery on a table only to find it has disappeared, later turning up elsewhere. Annette often remonstrates with the cheeky spirit with the words, 'Look Jenny, put it back.' She also tells Jenny not to frighten the pub's customers, especially the children.

ROWSLEY

Rowsley is halfway between Bakewell and Matlock, just south of Beeley and the southern entrance to Chatsworth Park. In the centre, just off the A6, is the driveway to East Lodge. This was a former hunting lodge on the Haddon estate owned by the Duke of Rutland of Haddon Hall, who held the manor of Rowsley. After being a private country house for many years, it was converted in 1984 and is now run as an exclusive hotel. According to director Ian Hardman, they are researching its history and in doing so have discovered the identity of their resident ghost.

They believe that she is Maud Sophia Levett, a nineteenth-century spiritual writer and former resident. This was her family home prior to her marriage to William Swynnerton Byrd Levett, from another branch of the Levett family. Her parents were Major Edward Levett (10th Royal Hussars) of Rowsley and his wife Caroline Georgiana, daughter of the Reverend Charles Thomas Longley, Archbishop of Canterbury. No doubt, with such a distinguished grandfather, Maud was not short of information when writing on religious themes.

Apparently Maud haunts one of the rooms, and it is said that etchings she made in 1898 can be seen in the window of that room.

Mr Hardman said: 'She is a friendly ghost and has never caused any real problems. Many guests have seen her over the years and some people even book into that room specifically to see if they can have a ghostly encounter.'

SHARDLOW

On the border of Derbyshire and Staffordshire, Shardlow was once a great port on the River Trent at the time when river transport was the only alternative to packhorses for taking heavy goods from one part of the country to another. Then, in 1761, a revolution in transport occurred when the first commercial canal in England was opened. The next sixty years saw canals being opened the length and breadth of Britain. Along the canals, inland ports like Shardlow grew up for the loading and unloading of goods. These in turn became new centres for trade.

The population of Shardlow quadrupled between 1788 and 1841, and the town became an important midpoint where goods were transferred from the wide riverboats to the canal's narrowboats. Warehouses for storage and distribution were built over spurs of the canal to facilitate loading and unloading of the barges, but the canal was soon superseded by the railway. Shardlow went into decline but retained its ghostly tales.

Spectres at the Malt Shovel

In 1799, Humphrey Moore, a rich farmer who lived in The Monastery at Old Wilne, was responsible for the building of the Malt Shovel public house (formerly the malt house), including the bay and the manager's house. During construction, Humphrey Moore found a tramp sleeping in the brewery and was so incensed that he supposedly threw him into a beer vat and drowned him, or at least that's one story. Another says that an unknown worker at the malt house fell into a boiling vat and died a horrible death. Whichever version you prefer, the fact is, someone actually haunts the cellars of the Malt Shovel. Pete Hanson, an ex-landlord, saw this ghost quite recently.

Just after a Mr and Mrs Howard moved into the Malt Shovel, some alterations were being made and, when plaster was removed, dry rot was found. The builder decided to leave the work while he sought expert advice, but the next morning all the bricks had been removed and were stacked neatly to reveal a wooden archway of an older door. Some time after this, a boy was working alone in the old loading bay – now used by furniture removers as a store. When he claimed he had been kicked down the stairs, everyone laughed, until the foreman entered the pub and ordered a double brandy. He had just been kicked down the stairs, and neither the foreman nor the lad ever went in there alone again.

The Haunt of the Lady in Grey

The Lady in Grey restaurant on Wilne Lane was formerly known as The Lodge. It was built by the Sowsby family, who had two daughters, Jeanette and Elizabeth.

The Malt Shovel.

The Lady in Grey restaurant.

When Mrs Sowsby died, she left all her jewellery to her youngest daughter, Elizabeth. Jeanette was furious and in a fit of temper buried the jewellery and refused to divulge its location. Elizabeth searched in vain until, around 1870–80, both sisters died. But even in death the younger still refused to give up her search.

A later occupant of The Lodge saw a lady in a grey period dress glide through his bedroom. He assumed it was his housekeeper playing tricks, so he rushed downstairs after the retreating figure – yet it suddenly vanished. Undeterred, he hurried into the kitchen where his housekeeper and some friends were talking. He still believed they had been playing a practical joke and had somehow managed to get back to the kitchen before him, but he could not account for the quick change of clothes. His guiltless housekeeper and friends were all in modern dress.

When the house became a restaurant, it was called the Lady in Grey, taking its name from the ghostly apparition of Elizabeth seen wandering through the house and garden and sitting on the balcony dressed in a long grey dress. This was almost certainly an advertising gimmick, but at least it was based on reality.

Several years ago, Harold Kyle lived at the Lady in Grey, and one evening after returning from playing saxophone in a local band, he was feeling rather hungry. He fancied a steak, so he pulled open the heavy door of the walk-in fridge and went inside. Almost instantaneously, the door closed behind him; yet it was designed not to close like that, as any length of time spent in those low temperatures could prove to be fatal. Fortunately, after ten minutes, his wife went to look for him and was able to release him. Both were convinced that the door could not have blown or swung shut.

Now known as the Thai Kitchen Restaurant – with an atmosphere evocative of Thailand – a less sympathetic background for the ghost of a Victorian lady would be hard to find. The owner, Gung, assures me he had no personal experience of the ghost of the Lady in Grey, but his mother and several of his staff have felt her presence, and that of a young boy, very strongly.

SOUTH WINGFIELD

Paranormal Investigations at the Old Yew Tree Inn

South Wingfield was called 'Winfeld' by the Anglo-Saxons, a name that almost certainly derives from the quantity of win or gorse that grew wild in the locality.

Ralph, Lord Cromwell, Lord Treasurer of England, was granted the lordship of Wingfield in 1440 and built Wingfield Manor. When he died in 1455, he had just sold the almost completed building to John Talbot, 2nd Earl of Shrewsbury. Several generations later it was the home of George, the 6th Earl, who in 1565 was given custody of Mary, Queen of Scots by Elizabeth I. Placed under house arrest, she was moved around the Shrewsbury's Derbyshire homes until her execution in 1584.

South Wingfield is still a small rural community, and the Old Yew Tree Inn, which is on the southern edge of the village, is the hub of village activity. There is also activity of another kind – ghostly activity! Over the years there have been numerous tales of hauntings: the feeling of a presence, hearing footsteps, doors bursting open and a wisp of blue smoke seen drifting around the building. One witness watched in disbelief as a picture hanging in the dining room moved up the wall before falling – a complete contradiction of the law of gravity.

All of this spirit activity prompted the landlord to contact the Derwent Paranormal Investigators, who in September and October 2004 undertook a series of investigations. Cameras and trigger objects were set up, baseline tests were taken and a pendulum dowsing experiment was set up in the cellar. A séance was carried out in the far end of the room next to the kitchen, during which doors banged, two strange orbs were captured on camera, the temperature dropped and one of the team felt a strange pressure building up around the back of his neck. The kitchen door was seen to move and noises were heard in the cellar. A second séance was held and there was a distinct smell of coconut oil in the air around the table. One team member could hear snoring behind her, and felt herself being pushed off the bench. There were drops in temperature and lots of presences were felt, including those of a woman in white and a middle-aged man.

Another member saw a long-haired figure in a crystal ball and felt it was an abbot or monk – such a person has been sighted at the end of the bar. The monk could be linked with the nearby monastic establishment that existed at Oakerthorpe (see The Peacock at Oakerthorpe) or he could have been giving spiritual guidance to Mary Queen of Scots during her enforced confinement at South Wingfield Manor. In the cellar they caught a couple of light orbs, although it was pitch-black down there. One team member got the impression of a long, dark tunnel, lit by torches or candles, leading to a large house. He sensed it was an abbey or friary and felt the terror of someone who was going down the tunnel but didn't want to. The atmosphere was very heavy and oppressive. Then, as the vision faded, the atmosphere lifted.

Five members took part in a further séance at the top end of the bar. Before long, one of the ladies felt someone was tickling her. A male team member felt cramp in his right shoulder and became very agitated as he began to sweat profusely. He appeared to be having difficulty breathing and started coughing. His neighbour also felt uncomfortably hot and began to visibly perspire. They both felt the presence of a woman in white and sensed the name Sarah. The temperature around them had risen to 25 degrees Centigrade while elsewhere it was 19 degrees. Making contact with the white lady, they were told that she died in the night trying to make a drink; her nightgown had caught fire and she burned to death. As the team members were in obvious discomfort, the séance was ceased and almost immediately the temperature around them dropped 6 degrees.

At the monk's end of the bar the team conducted a further séance and the presence of the abbot was felt by everyone. One female member began to feel very upset and started to cry for no obvious reason. A male member felt cold spots around him and connected with a man of God. When the presence was asked if he were a traitor, the room went very cold. When it was asked if he had killed himself, one member could taste something foul in his mouth and felt sick with stomach pains. A dictaphone had been playing throughout the séance and when played back the team could hear grunts and growls and lots of heavy breathing; but most startling of all were the words 'help me', 'let me out', and 'blessed wine'.

There is no doubt that the Old Yew Tree Inn is very spiritually active and has been labelled the most haunted pub in Derbyshire. Who are we to argue?

The Old Yew Tree Inn has been labelled the most haunted pub in Derbyshire.

STONEY MIDDLETON

Murder at the Moon Inn

Stoney Middleton is often bypassed by people travelling along the A623; but if you stray from the main road, the area around the church is unexpectedly cosy, with charming cottages and colourful gardens and a little brook on its way to the grounds of the old hall. However, the looming crags that look down on Middleton Dale tell a completely different story. This is the area that many years ago had more than its fair share of seedy boarding houses frequented by tramps and navvies. But for those who couldn't afford a night's accommodation, there was always a warm alternative. Homeless men and women spent the winter nights sleeping on the edge of the lime kilns that burnt in Middleton Dale, enjoying the treacherous luxury of the warmth generated by the burning lime. Sadly many were accidentally cremated because, if the wind changed direction, the sleepers could either be suffocated or overcome by the fumes, and many rolled into the furnace below.

Around the mid-eighteenth century, this area attracted a large number of itinerant tinkers, hawkers, pedlars and general ne'er-do-wells who toured the country; they visited fairs and Wakes week festivities, selling cheap trinkets. One such pedlar was a sixty-year-old Scots man who arrived for the Eyam Wakes around 1750, and although he had a licence to operate he was disliked by the local pedlars, who tried to undercut him. This no doubt annoyed the Scottish pedlar and he decided to report the others for trading without licences, because even then it was illegal for street traders to operate without a licence.

As the other pedlars were ordered out of the parish, they vowed to get revenge on their informant. This was overheard by the landlord of the Bull's Head, Eyam, who at the end of Wakes week sent someone to accompany the Scottish pedlar as far as Stoney Middleton. But instead of leaving the area, the pedlar stopped off at the Moon Inn, and it was there that the rival pedlars murdered the Scotsman. The landlord at the time allegedly turned a blind eye. They then took his body by horseback to Cael's Wark (Carlswark Cave), near Lovers Leap in Middleton Dale, where it was discovered about twenty years later by a man called Peter Morton, who was led there by a dream. The body was only recognisable because of its attire, and the bones and buckle shoes were boxed up and kept in Eyam church. After a number of years, when no one had claimed them, the nameless pedlar was buried in the churchyard and a bell-ringer named Matthew Hall took the shoes. No one was ever charged for the murder, but if you ask any of the locals they will tell you that the ghost of the Scottish pedlar still haunts the Moon Inn.

Until recently, along the northern stretch of the A623 – the main road that passes through Stoney Middleton – there was Lovers Leap Café, which had previously been

The Moon Inn.

an inn called Lovers Leap Inn. Built into the naked rocks that beetle over the property, it is still an eating house, but the old name has gone and with it the tragic story that happened here around 1762. Hannah Baddalay lived with her family in a cottage in Stoney Middleton. She was courting a man named William Barnsley, but when he broke off their relationship Hannah threw herself from the steep limestone cliffs. Although she intended to end her life, her voluminous skirts acted like a parachute and broke her fall. She lived for a further year, probably crippled by her fall, but her ghost is said to re-enact her leap – which is why the inn on the site was given the name Lovers Leap Inn. It was a great tourist attraction a century ago and horse-drawn brakes used to take their customers to the Lovers Leap Inn to enthral them with the story as they gazed in awe at the limestone crags.

SWARKSTONE BRIDGE

Strange Lights Seen at the Crewe and Harper Arms

Swarkstone Bridge is more than just a bridge. With its seven arches, this is a ¾-mile-long causeway that carries the A514 as it crosses the River Trent and an area of low marshy ground. Originally, the only way to cross the fast-flowing river was by a ford or ferry, the earliest bridge being documented in 1204 as the Ponte de Cordy. In 1327, a surveyor was appointed by Repton Priory to maintain the bridge, and a chapel was built on the southern end, with a priest appointed to collect prayers and tolls from travellers. This bridge was finally swept away by flood waters in 1801, when the present bridge was built reusing stone from its medieval predecessor.

A few years ago, a woman who worked at the Crewe and Harper Arms at Swarkstone, at the end of Swarkstone Bridge, had just reached the end of her shift and was ready to leave when glancing out of the window she saw strange lights near the river. She informed her boss and they went out to investigate, feeling sure it was someone messing about on the river or up to no good. As they ran round the building, they could clearly see the lights darting just above the water. The lights were round and white and, as there was no moon, they were not simply the moon's reflection. Then the witnesses heard a terrifying scream that did not sound human, and one of the lights seemed to be moving frantically towards the other, then darting back again. The onlookers watched as the lights disappeared into the water and the air became suddenly still. They discussed what they had seen as they walked back to the pub, but they were both totally mystified as to what had caused the strange events.

They were aware of the local legend of the two sisters who each lost a lover when they drowned in the murky waters while trying to cross the river. The sisters were devastated and as a memorial to their lovers they built the original wooden bridge that crossed the river at Swarkstone. Could the lights therefore be the spirits of the lost lovers re-enacting that fateful night?

Other people have also seen the wraiths of the two sisters, who on stormy nights, when the fast-flowing river is dangerously swollen, are seen searching endlessly for their lost loves.

TADDINGTON

The Queens Arms – Haunt of at Least Three Ghosts

The village of Taddington was once a major centre for the lead mining industry, so it's not surprising to find a pub called the Miners Arms that reflects the area's rich lead-mining heritage. However, the pub got a name change in 1887 to mark Queen Victoria's Golden Jubilee and is now the Queens Arms. As a village pub it dates back to 1736, although it was a farmhouse before then. The cellar has also been used quite regularly as a morgue in an arrangement with the local coffin-maker, who was based across the road. So with that kind of usage it's not surprising to find some spirits here other than the liquid variety.

According to Kirsty Allen, daughter of the landlord and landlady, they inherited a resident ghost called Fred. His full identity is lost in time, but he's certainly still active around the bar, and when things go missing – and they invariably do – Fred is always blamed. It's quite usual to find ghosts like Fred tampering with electrical things like music centres but, according to Kirsty, when the village was suddenly plunged into darkness due to a power cut, the only electrical thing that continued to work was the pub's music centre, a mystery that completely baffled staff and customers.

I asked Kirsty if there were any parts of the building that were more spiritually active than others. She said Fred wandered around. He has been sensed in the living quarters upstairs and in the cellars below. 'And I'm not taking you down there,' said Kirsty with a shudder. 'I never go down there. It's far too creepy.'

She confirmed that the cellars had been used as a morgue and that strange things happen down there. I asked, 'What kind of strange things?'

'Well just after the recent smoking ban, we collected up all the ashtrays, those thick, green ceramic ones that we had in the bar, and put them on a shelf in the cellar. We were just clearing up one night when suddenly there was a mighty smash and, when we went to investigate, one of the heavy green ashtrays was smashed to pieces all over the floor. It was impossible for it to have fallen off the shelf as the ashtrays had been pushed to the very back, so was it Fred making known the fact that he didn't approve of the smoking ban?'

'Have you ever seen Fred?' I asked.

'No, but I've seen the girl in white. I've seen her walk from the cellar across the bar and disappear into the kitchen.' Kirsty described her as a teenager dressed in Victorian clothing, then told me about another ghost, an old man who regularly sits in the corner by the fire where he died apparently many years ago. Kirsty can trace her family routes in Taddington back for generations and thinks this man may have been her great-grandfather who had come back in spirit to keep a watchful eye on her.

'People complain of feeling cold when they sit in that corner,' explained Kirsty, 'and they have reason to. When I'm hot and flustered, I go and sit in that corner and soon feel much calmer and a lot cooler.'

The Queens Arms, which now serves as the village shop and hub of village activities, was once one of six pubs in Taddington, four of which stood along the main road. The Star House next to the church used to be the Star Inn, and according to a book called *Notes on Derbyshire Churches* by J. Charles Cox, the Star Inn had a rather strange receptacle for the washing of its beer glasses – the church font. How it got there and why is unknown, but in September 1939 this ancient font – which could be 1,000 years old – was rescued and returned to the old church of St Michael's and All Angels, where alongside some interesting monuments, brasses, and a register that dates from 1640, it can still be seen.

The Queens Arms.

The corner of the lounge where it always feels cool.

TANSLEY

My Gran Haunts The Tavern

Who knows what you are going to find when you start tracing your family tree. You can often discover a few surprises, both pleasant and otherwise, because every family has a few skeletons in the cupboard and at least one black sheep. But would you be prepared to find that you have a family ghost?

A few years ago, The Tavern at Tansley was known as the George and Dragon. It was originally a farmhouse and ale was served from the farm kitchen. In the middle of last century the landlady was a Mrs Jones, and according to her granddaughter Louise Bastard, she still haunts the pub. When Louise's mother and father married in the 1960s, they went to live at The Tavern with her father's mother. A few years ago, Louise's mother and a friend went to The Tavern for a drink and she told the barman she had once lived there and that her mother-in-law had run the bar.

'And she still does!' the barman replied. 'We often sense her presence in the bar and cleaners have seen her sitting in there.'

'Apparently she seems quite happy,' said Louise. 'She just sits there in the corner of the bar with a gin and tonic in her hand.'

The Tavern at Tansley.

TICKNALL

Mrs Soar: The Benevolent Ghost at the Staff of Life

Ticknall is first recorded in the early years of the eleventh century as 'Ticenheale', meaning 'nook of land where young goats are kept'. The area was well wooded until the time of Elizabeth I, when goatherds could still be found there. Sixteenth- and seventeenth-century Ticknall lay amongst great arable open fields, two-thirds of which by the mid 1760s belonged to the Harpurs of Calke Abbey. By the nineteenth century, virtually everyone in Ticknall worked on the Harpur Crewe estate, and now Ticknall is full of reminders of Harpur Crewe patronage. The fir trees, in pairs on either side of the road, were planted in 1876 to commemorate the marriage of Sir Vauncey Harpur Crewe to Isabel Adderley. The fourteen attractive cast-iron standpipes or 'taps' installed in 1914 by Sir Harpur Crewe still dot the roadside; each tap is complete with a stand and a handle, and water is issued through the mouth of a lion's head. Although piped water was introduced in the 1950s, some of these taps are still in use.

The church of St George was built in 1831 on the site of the church of Thomas Becket. This former church proved so difficult to demolish, even when gunpowder was used, that parts of it – the south-west corner of the tower and the altar window – remain standing. The area around the old church is said to be haunted. People have seen the kneeling figure of a woman in blue, deep in prayer, by this Gothic arch, and there is also the ghost of a wailing, golden-haired child dressed in the clothes of the Elizabethan era; but don't approach him or he will simply vanish.

Ticknall has some interesting buildings, including a stone roundhouse or lock-up. The inmates of these small prisons were usually drunks, put there for their own safety or because they were a nuisance, but this Ticknall lock-up has a strong association with the landlady of the Staff of Life. This village pub is a fifteenth-century red-brick building with a chequered history. At one time it was a pig farm, a bakery and a pub named the Loaf of Bread. It's also haunted by a previous landlady named Mrs Soar, a benevolent ghost who supposedly clears up after everyone. Mrs Soar had a key to the village lock-up, which no doubt held some of her best customers on a regular basis. It is said that she used to let the drunks out after they had been locked up or kept them supplied with liquor while they were confined. Sometimes they came out drunker than when they went in because a common practice was to supply them with drink through a straw threaded between the bars of the small window.

TIDESWELL

Old Sarah Haunts the George Hotel

Situated between bleak moors and a chain of lovely dales, the lonely little town of Tideswell, 900 feet above sea level, got its name from one of the area's many wells that ebbed and flowed like the tide. Tideswell is perhaps best known for its parish church with eight pinnacles. Often referred to as the 'Cathedral of the Peak' because of its grand proportions, it was built at a time when Tideswell was an important market town and lead-mining centre. Located at the eastern side of the church is the historical George Hotel, but be warned: the George Hotel has one too many spirits in the bar.

When Dale Norris and his wife Peggy took over the George Hotel, Dale's father, Ernest, was so convinced they had an intruder that he stayed up one night to confront the person. Inevitably, as the place quietened down and Ernest was left alone, he made himself comfortable on the downstairs sofa and began to snooze. He woke abruptly in the early hours of the morning, chilled to the bone. Standing staring at him over the bar was a woman that Ernest described as around fifty-five years old and dressed like a serving wench in a Victorian melodrama. Her long Victorian dress and mop cap were so clear that at first he thought she was a woman prowler – until she vanished into thin air.

So as not to alarm anyone, Ernest didn't mention this until several nights later when a customer asked if they had seen anything strange. When Ernest admitted he had, he was told that, according to local legend, the phantom prowler is 'Old Sarah', who skulks around the eighteenth-century pub in search of her husband. They say around Tideswell that half a century ago she scared away a party of guests with her appearing and disappearing act – so be prepared!

The George Hotel.

TUPTON

Drowning at the Royal Oak

The name Tupton is believed to be derived from the Anglo-Saxon term 'Topis Tun', meaning the farm belonging to Topi, later changed to Topetune. Like many similar villages round here, Tupton was originally a small agricultural village, but that changed in the early 1800s when coal mining came to the area.

Today's Ashover Road follows the same route as the eighteenth-century Old Tupton to Ashover turnpike road, beginning at the Royal Oak, where a few years ago the original board that advertised tolls was discovered in the cellar. This road is significant to our story as this was the route that Samuel Lomas, the Ashover resident and parish clerk, was taking back home in December 1845.

Sixty-nine-year-old Samuel Lomas had attended a funeral at North Wingfield church in the afternoon and, returning to Ashover, had broken his journey by calling in at the Royal Oak public house. He drank gin and water, and left there a little after eight o'clock; but instead of going straight onto Ashover Road, he decided to take a shortcut through the farmyard behind the pub. In the farmyard was a small pond, which was no more than twenty inches deep, and it was here that the body of Mr Lomas was found the next morning. The verdict was 'accidental death by drowning'. But on the anniversary of his death be sure not to linger around the Royal Oak – because on those cold December nights people have reported hearing the sound of spluttering as the ghost of Samuel Lomas re-enacts the manner of his demise.

The Royal Oak.

WARDLOW MIRES

The 400-Year-Old Cat Found Bricked in the Wall

Wardlow Mires is a tiny hamlet that sits astride the A623, almost midway between Stoney Middleton and Peak Forest. It's a lonely place with under fifty inhabitants, and many years ago this was the site of hanging and gibbeting. The infamous highwayman Black Harry was hanged at the Gallows Tree at Wardlow Mires. Gibbeting the corpse was popular right up until the mid-nineteenth century and meant suspending the body of a lawbreaker in a metal frame at a busy and obvious place in full view and leaving it there until it decomposed. Gibbeting was used as a method of humiliation and a deterrent to others. Often the body was smeared with tar so that it remained longer at the scene of the crime. A highwayman who robbed a stage near Duffield in 1750 was gibbeted and smeared with tar – but to stop further humiliation, and to hide the victim from the world's gaze, his friends set fire to his body.

Could this be the reason why, in 1720, when the old turnpike road was under construction through Wardlow Mires, seventeen stone coffins containing human remains were uncovered here. One is still outside the Three Stags' Heads.

Pat and Geoff Fuller run an active farm from their seventeenth-century farmhouse, which has also been the Three Stags' Heads since 1760. But apart from the macabre history of the area and the coffin outside, what singles out this isolated farmstead from thousands of others in the Peak District is what is inside.

When knocking through a wall at the Three Stags' Heads a few years ago, the builders made a remarkable discovery – the mummified body of a cat bricked into the wall. In medieval buildings it was customary to secrete a dog or cat within the walls as a ritual sacrifice, a tradition that dates from the pagan past when it was believed that no building would be secure until a living creature was interred in the foundations. This was done in the belief that the animal would ward off evil, and it's not unusual to hear the phantom cries of these unfortunate creatures. It is, however, rare to be able to see them perfectly preserved like this 400-year-old feline in the bar of the Three Stags' Heads. Geoff also showed me a child's shoe that had been found secreted under the stairs. Shoes were used like good-luck talismans and were regularly hidden under floors or stairs of houses, and were also left in old lead mines to placate 'T'Owd Man'. This old custom still exists: old shoes or boots are attached to the bridal conveyance of a newly married couple to wish them good luck. But hopefully the habit of bricking animals into walls has long gone.

The Three Stags' Heads at Wardlow Mires.

The 400-year-old cat that was bricked up in the wall at the Three Stags' Heads.

WINSTER

The old market town of Winster, which first appeared in the *Domesday Book* as Winsterne, is situated in a valley and climbs irregularly up the sides of a rocky eminence six and a half miles south-south-east of Bakewell. In the centre is the restored market hall that dates from the late seventeenth or early eighteenth century. It is a reminder of when cheese markets and cattle fairs were a prominent feature of local life, and has the distinction of being the first Peak District property acquired by the National Trust.

Across the road from here is the old Angel Inn, which has a paranormal history. There are accounts of doors opening and closing, and of ghostly footsteps. A murder supposedly took place in one of the bedrooms – possibly a strangulation, because some time ago a lady sleeping in that room awoke, convinced that she was being choked by ghostly hands.

But most bizarre is the story of the headless bride. One day a lady at the Angel Inn was sitting at her dressing table concentrating on her reflection. Behind her the door was open, and through the looking glass she had a clear view of the first-floor landing and the flight of stairs to the upper floor. Suddenly her attention was diverted from her own reflection to that of a white-clad figure slowly descending the upper flight of stairs to the landing outside her open door. The figure was a young woman dressed as a bride, but the most terrifying aspect was the absence of a head: the neck just faded into nothing. As the figure walked unhesitatingly towards her, the lady at the dressing table fainted.

There appears to be no link between the Angel Inn and a bride, and there is no explanation as to why this spectre should be headless, beheaded accidentally or otherwise. Despite the sign over the archway, the Angel Inn closed its doors as an inn long ago, and the three-storey building is now a private residence.

Winster Hall: Haunt of a Heartbroken Lover

Although this impressive Georgian building is now a private residence, Winster Hall has had quite a chequered past and qualities for inclusion in this book because at one time it was a public house and restaurant.

Built in the eighteenth century from grit stone brought from Stancliffe Quarries in Darley Dale, it replaced an earlier house built by Francis Moore in 1628. The Moore family were lawyers and mine owners. Llewellyn Jewitt – editor of *The Reliquary* and a famous antiquarian, artist and collector of Derbyshire folklore and legends – lived here between 1867 and 1880. It's been a firearms factory, a home for disabled persons during the Second World War, a public house and restaurant.

The restored market hall and, across the road, the old Angel Inn, haunt of a headless bride.

Winster Hall, haunted by a heartbroken lover.

The hall has for many years had a reputation for being haunted by the spectre of a woman linked with a rather tragic love story. She is believed to be the daughter of the house who, having fallen in love with the coachman, was being forced to marry someone selected by her parents, someone they considered more suitable for a lady in her position. Tragically, the night before her wedding, the lovers climbed to the top of the house and, clinging to each other, jumped over the balustrading at the parapet to their deaths. The young lovers were buried opposite the door of Winster church, but the wraith of this unhappy girl is still said to haunt Winster Hall and the forecourt where she met her death.

The Ghostly Echo of 'Three Blind Mice' at the Miners Standard

The Miners Standard is a seventeenth-century free house just outside the village. It was built originally as a farmhouse by the Parker family in 1653, and a tablet over the door shows the date and initials EP, EP and FP. Locals will tell you that it stands for 'Every Person Entering Pays For a Pint', but in fact it's the initials of the original owners: a yeoman farmer named Edward Parker, his wife Elizabeth and son Francis. The earliest building was quite substantial with four rooms on the ground floor, five on the second floor, two stables, one carriage shed, two piggeries, a brewhouse and a small place for sundries.

The mention of a brewhouse is interesting, confirming that it was not unusual for farms to brew ale and serve it to thirsty voyagers. Here there would be no shortage of travellers because just to the rear of the building is the ancient Portway, one of the oldest of Derbyshire's trade routes. This would ensure a good passing trade, which was boosted by the local lead-mining community of Islington.

From early days, the toxicity of lead was known to be a problem for both people and animals, but it was widely believed that ale was an antidote to lead poisoning. It's therefore not surprising that the miners rejoiced in consuming plenty of medicinal ale.

Although the building continued to be a working farm, it became known as the Miners Standard – after the name of the wooden dish used by miners to measure lead ore.

Lead mining went into sharp decline during the second half of the nineteenth century when richer and cheaper lead reserves were found elsewhere. As these supplies flooded the market, Derbyshire lead became uneconomical and the last big mine closed in 1939, bringing to an end over 2,000 years of lead mining.

With such a long and chequered history, it's not surprising to find that the Miners Standard has its fair share of ghosts. One of the most notable can be traced to 1839, when John Smith, listed as a butter dealer, lived here with his wife Mary and their three young daughters, Catherine, Dorothy and Emma. It's not just the sound of the footsteps of an unseen person; it's the haunting tune of the first bars of the old nursery rhyme 'Three Blind Mice' being hummed. Customers who have caught the low, quavering notes say that the voice is of a lady, as if soothing a small child to sleep.

Understandably this has attracted many paranormal groups who allege that the voice is that of Mary Smith singing to her little daughter Emma. They also claim to

The Miners Standard.

have made contact with a man who walks around upstairs. The name George has been mentioned and the current landlord can confirm that this was the name of his father-in-law, who had the bedroom where the presence has been detected. George's ashes are buried under the urn by the side of the car park.

'I believe you are haunted!' I said to the landlord. He laughed. It was obviously a remark he had heard frequently.

'We most certainly are,' he confirmed with a good-humoured grin. 'But it doesn't bother us.'

WIRKSWORTH

Rowdy Children Haunt The Red Lion

Wirksworth was once the centre of a vast lead-mining area which had previously brought the town its prosperity. Stimulated by the demand during the sixteenth and seventeenth centuries, lead mining expanded to become a major industry in the limestone country of Derbyshire. By the eighteenth century, Wirksworth was the third largest town in the county. When lead mining was at its height in the seventeenth and eighteenth centuries, Wirksworth was a major dropping-off point on the stagecoach routes. It's now a quaint little town with lots of quirky buildings and some very imposing ones too. Our destination is the Red Lion just off the Market Place. This former coaching inn was rebuilt in the eighteenth century but may date back to medieval times. It has a fine assembly room that hosted the town's civic and social functions before the town hall was built, and it's also haunted.

I had heard that in the coaching era this was an important staging post, but one day, as a coachman was trying to manoeuvre his coach through the archway, the horse suddenly bolted and, taken by surprise, the coachman was decapitated. Now his headless figure has been seen wandering the premises.

I asked Peter, the proprietor, if he knew anything about the ghost of a headless coachman who now haunts the building. When he confirmed the story, I asked if he'd seen him, to which he replied, 'I've seen many people legless but never anyone headless.'

Many people have taken photographs with their digital cameras both inside and outside the Red Lion and there have been a lot of orbs captured. Orbs are believed to be the first manifestation of a ghost. Bedrooms 6, 7 and 8 on the first floor seem to have the most spirit activity, and guests have captured orbs when taking photographs in these rooms.

Since major alterations took place two years ago, there has been enough evidence of paranormal activity to attract the attention of a Wolverhampton-based team of ghost hunters, who visited the Red Lion in the spring of 2010. They confirmed that there is spirit activity all around this old building. That first floor corridor is the most active part of the building and the group stated categorically that this is due to three children. An older child, a boy probably around eighteen years old, often chases a younger boy and girl along that corridor. The investigators picked up the girl's name as Anne. That area of the first floor is in the oldest part of the inn and could date back to the sixteenth century, so children in period clothing would be quite at home here, although why they should have remained – like all the ghosts and spirits we have encountered in the pubs, inns and hotels of Derbyshire – remains a mystery.

The Red Lion Hotel has a headless coachman and three unruly spectral children.

ALSO AVAILABLE FROM AMBERLEY PUBLISHING

PARANORMAL DERBYSHIRE
Jill Armitage

978 1 4456 0081 9
£12.99

Available from all good bookshops or order direct from our website
www.amberleybooks.com